CREATE WITH ARTISTS

- AN ART ACTIVITY BOOK FOR EVERYONE -

"Boost your creativity with tips from some of the world's top artists and designers like Viktor&Rolf, Marlene Dumas, Rop van Mierlo, and Rineke Dijkstra. This book is packed with original workshops that offer all kinds of creative challenges to jumpstart your imagination and show you new and exciting ways to explore ideas at the kitchen table, in nature, or out in the city. Create with artists and light the creative spark inside you. Or get creating with your friends, family, co-workers, or classmates."

BEATRIX RUF
Director, Stedelijk Museum Amsterdam

WITH THANKS
TO ALL
THE ARTISTS

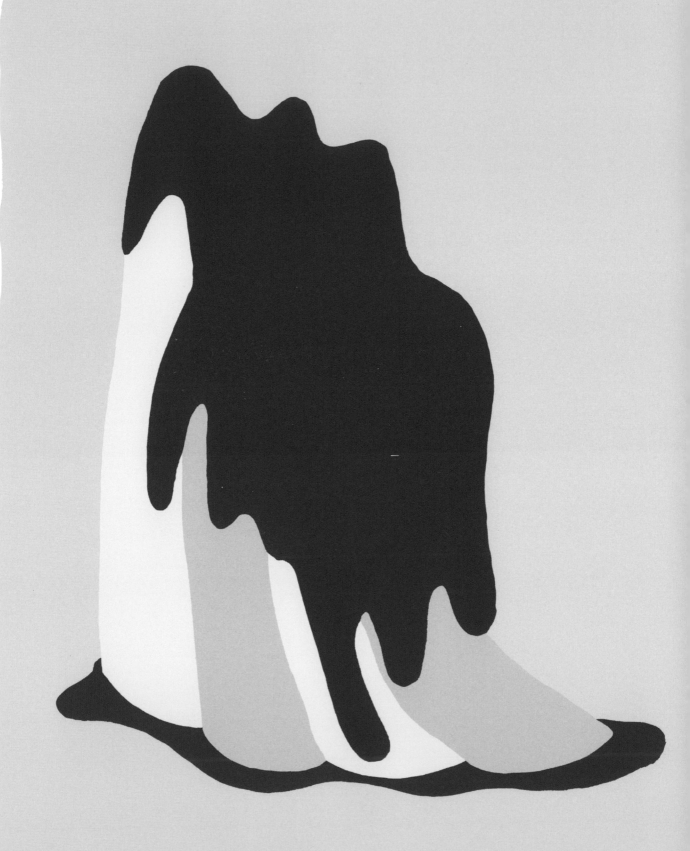

IS THERE SUCH A THING AS A RECIPE FOR ART? OR CREATIVITY?

For over ten years, we've been organizing weekly workshops with artists for the Stedelijk Museum in Amsterdam. People were having so much fun and were asking for more. Then we had an epiphany. Wouldn't it be nice to collect these workshops into a book so we could share them with even more people? We thought so.

Our imaginations ran riot. And we soon dreamed up "the big workshop book," chock full of clear and accessible recipes for creativity. For everyone who loves to sample different tastes. But – luckily – this book isn't some magic cookbook. So don't expect ready-to-use recipes for pre-cooked end results, success guaranteed. Our advice: DON'T try to make a carbon copy of the contributing artists' work. It's okay if your soufflé sags in the middle, or your risotto's too dry or too moist.

So how do you use this book? In the 23 workshops, artists get your creative juices flowing by asking questions. These are the same questions they use – and sometimes struggle with – when making their work. Questions that pop up again and again, as well as questions that have never been asked – all designed for you to also think about, play with, and most importantly, use creatively.

These workshops are the start of new explorations. Artists help you create, and guide you in finding your own style, language, ideas, and answers. There are no rules, no rights and wrongs only freedom and some tips. With a bit of luck, the book will generate exciting new "problems" and questions you can't wait to explore. How do you turn a garbage bag into a tailored suit? Pee into the wind? Plant a wild garden? We can't wait to see your creations, share them with #createwithartists.

We'd like to give a big "thank you" to all the artists for coming up with so many unique, and very different, recipes for creativity.

Have fun!

RIXT HULSHOFF POL AND HANNA PIKSEN

TABLE OF CONTENT

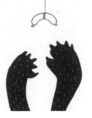

WHAT DO YOU FEEL LIKE DOING?

DIRTY HANDS	**LOW BUDGET AND AMAZING**	**GO TO EXTREMES**	**OUT AND ABOUT**	**BACK TO THE FUTURE**

GO…	GET…	DO…	TAKE…	BUILD…
break pencils with Rop van Mierlo P.12	a roll of garbage bags and make an outfit with Viktor&Rolf P.32	something radical and lose yourself with Marlene Dumas P.18	a mirror out hunting with Marijke van Warmerdam P.22	a spaceship with Jantje Fleischhut P.56
digging and raking with Job Schroën and Piet Oudolf P.26	the contents of your fridge Johannes Schwartz P.36	what you want with Lawrence Weiner P.52	a spade and go wild gardening with Job Schroën and Piet Oudolf P.26	a science fiction city with Persijn Broersen & Margit Lukàcs P.74
cook for animals with Johannes Schwartz P.36	flour, salt, and water with Maria Barnas P.44	Liam Gillick's three-year workshop P.70	to the street with pen and paper with Jan Rothuizen P.80	something from the future with Joep van Lieshout P.108
munch on bread dough with Maria Barnas P.44	ordinary materials with Jantje Fleischhut P.56		a natural portrait with Rineke Dijkstra P.96	
mold clay with Marcel Wanders P.48	empty bottles to build a boat with Floris Hovers P.100		the boat you made with Floris Hovers P.100	

SUPERFAST

3, 2, 1 AND...
make a
one-minute
sculpture with
Marcel Wanders
P.48

cut and paste a
banner with
Bob van Dijk
P.92

built a boat with
Floris Hovers
P.100

be quick on the
draw with
Mark Manders
P.104

LETTERS AND WORDS

WRITE A ...
poem with
Maria Barnas
P.44

tag with
Mick la Rock
P.60

soft map with
Jan Rothuizen
P.80

a word in your
very own alphabet
with Moniker
P.88

TEAMWORK

TOGETHER ...
catch a photo
with an assistant
photographer
and Marijke van
Warmerdam
P.22

go gardening with
Job Schroën and
Piet Oudolf
P.26

play with design
rules with
Moniker
P.88

draw words with
Mark Manders
P.104

A PARTY

MAKE...
a party outfit with
Viktor&Rolf
P.32

a flat chair with
Ineke Hans
P.64

a banner for your
secret love with
Bob van Dijk
P.92

FASHION

DESIGN...
challenge with
Viktor&Rolf
P.32

a personal
scarf with
Klaartje Martens
P.40

an alien
necklace with
Jantje Fleischhut
P.56

a très cool bag
with Puck & Hans
P.84

– ROP VAN MIERLO –

CAN YOU PEE
INTO THE WIND?

PENCIL

PAINTBRUSH

INK OR WATERCOLOR

SPONGE

WATER CONTAINER

PHOTO OF AN ANIMAL

PAPER

(BAMBOO) STICK,
AT LEAST 60 CM LONG

ADHESIVE TAPE

EGG TIMER

HAMMER (AND SAFETY GOGGLES)

DRAWING INTO THE WIND

When Rop starts a drawing or painting, he has no idea how it's going to turn out. He describes it as feeling as if he's always peeing into the wind. This workshop will show you seven different ways to draw animals. Six times into the wind, and the first time with the wind at your back to help you along.

Set your egg timer for six minutes. You've got to complete each assignment within this time limit.

1. Get your pencil, paper, and animal picture, and sketch the animal from the photo.

2. Hang a sheet of paper on the wall at head height. Stand in front of it – your toes have to touch the wall. Get your pencil and draw the animal again. Important: your nose must be no more than 10 cm away from the paper.

3. Tape your pencil to the end of a stick. Place a sheet of paper on the table, with the photo next to it. Now stand on a chair and draw the animal again.

→

4. Dip the handle of your brush into the ink or paint and draw the animal.

5. Dampen the sponge and wet the paper on both sides. Take the paintbrush and sketch the animal as well as you can on the wet paper. Don't worry about the colors streaking.

6. Dip a large bit of your sponge in the ink and paint the animal on a very small piece of paper.

7. Put on your safety goggles, pick up your hammer, and smash your pencil to bits. Now, use whatever's left of the pencil to draw the animal.

HANG UP YOUR ANIMALS. DOES EACH ONE HAVE A DIFFERENT PERSONALITY? WHICH ONE DO YOU LIKE BEST?

TIP

"What makes a good drawing? Is it skill, the materials you use, the technique, concentration, training, talent, luck, or a combination of all these? Concentrate and make your drawing as good as it can be. Don't be put off by things you can't control – like a scratch, or streaky ink. Just let it happen. The more you let go and focus on the drawing you're making, the more fun the result."

During Rop's workshop at the Stedelijk Museum

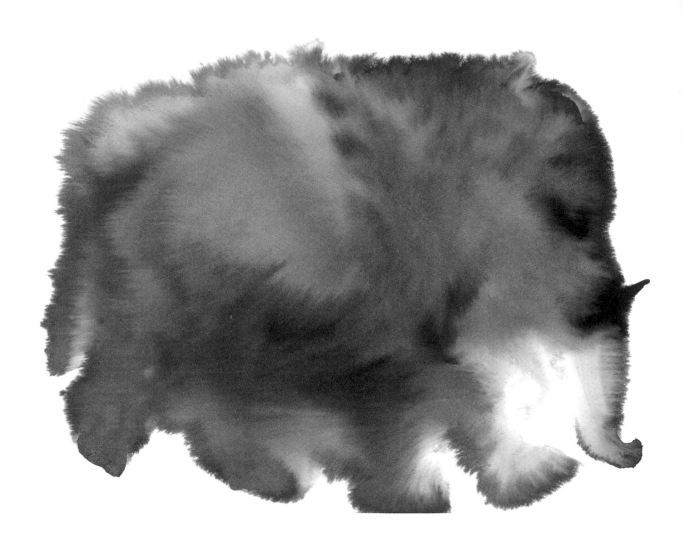

'Elephant', from the series *Wild Animals*, 2014

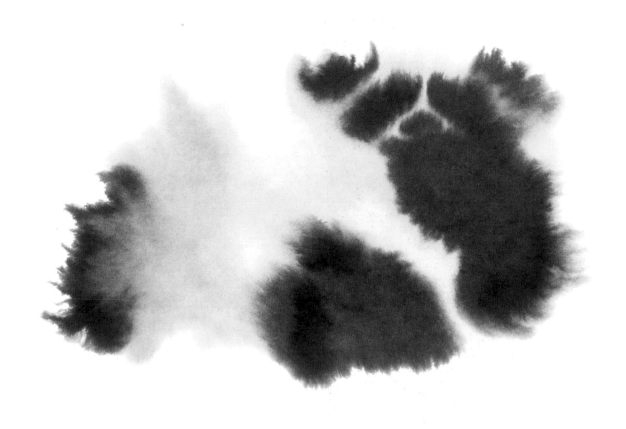

'Panda', from the series *Some Logic*, 2014

ROP VAN MIERLO almost always draws animals. Why? Because ever since the dawn of man, humans have tried to control animals. So Rop tries to find ways to set animals free. In his books *Wild Animals* and *Some Logic*, creatures break through the lines and break the rules. Rop lets chance play a big part.

HOW DO YOU MAKE EMOTIONAL PORTRAITS BY BECOMING SOMEONE ELSE?

EVOLVE YOURSELF WITH PORTRAITS

SIMPLE MATERIALS SUCH AS
PENCILS, BRUSHES, INK, OIL
PAINT, CANVAS, PAPER

A COLLECTION IMAGES
OF PEOPLE

YOUR ATTITUDE,
EXERCISE THE EYE AND
THE MIND

Art is not only made by the heart. It is not only a drain for pain.
You've got to train your brain. Exercise the eye and the mind.
Educate yourself, exhaust yourself, and get rid of yourself.
What you need in terms of attitude is the most important.
Be prepared to play, act, and take on different roles.

What you need in terms of materials is simple. Keep it low tech
and cheap, such as pencils, ink, or oil on paper or canvas. For
source material collect images of people from any public media
you prefer, like newspapers, magazines, photo albums, the Inter-
net...whatever your likes and dislikes are.

· The portrait as Rorschach test
Pretend you are a psychologist. Design a few new tests to analy-
ze yourself and the others. (First look up Rorschach test). Try to
be clever. Do you think art does help to heal?

· The portrait as voodoo
Find or imagine all the bad guys you want to get rid of. Use the
portrait as an instrument to take back the power. To exorcise
your fear. Paint what frightens you. Give it a name.

· The portrait as emotional blackmail
Go and look at, even if you don't actually read it, Charles Darwin's
The Expression of the Emotions in Man and Animals, first publis-
hed in 1872. (Get the third edition from 1998.)
Try to paint ambiguous expressions, or mixed messages. Try
false tears and distrust, make your own couples and groups.

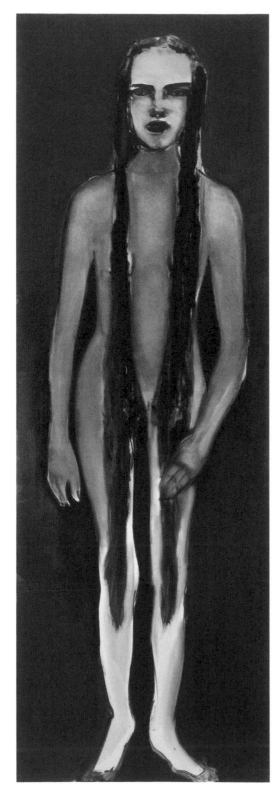

Magdalena (Newman's Zip), 1995

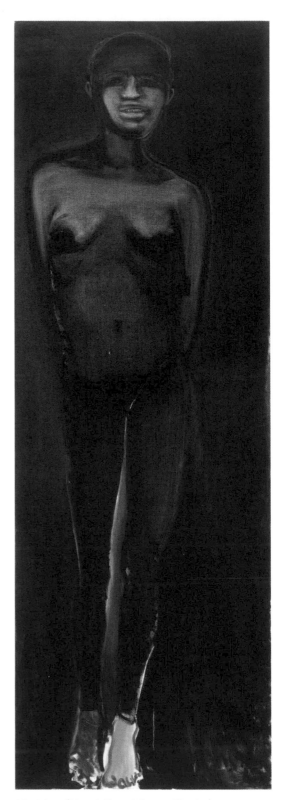

Magdalena (Manet's Queen/ Queen of Spades), 1995

HOW DO YOU MAKE EMOTIONAL PORTRAITS BY BECOMING SOMEONE ELSE?

TIP *"Take your time. Take a long time to look at and think about what you have collected – the faces and the body language and what you want to do with it. But then, at last, act fast!"*

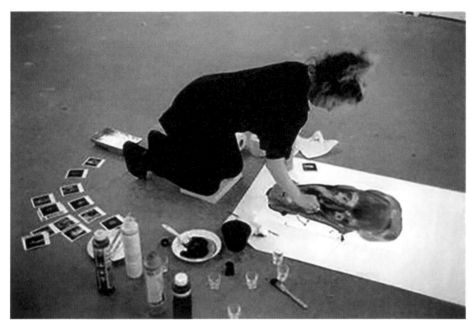

Marlene working in her studio

MARLENE DUMAS In the work of Marlene Dumas, it's all about the human figure. She explores preconceived ideas and interpretations that surround images. And you can see it from the titles she gives her work. Her drawings and paintings aren't only direct and expressive. They also make you think about love and yearning, violence and death. To produce this kind of work you sometimes have to get rid of yourself first. Marlene thinks that live models always try to look attractive or very neutral. And you can't take them home in a plastic bag to look at more closely later. Can you become someone else and make an emotional portrait? Marlene's going to help you jump into the deep end.

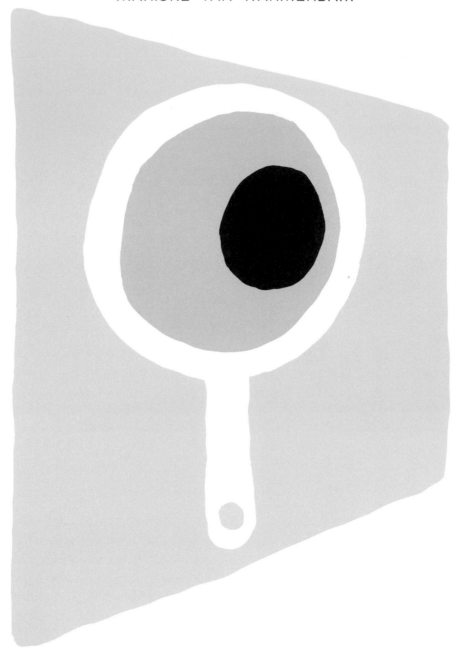

MIRROR, ЯORЯIM
IN THE HAND, WHO CAPTURES
THE BEST IMAGE OF THE LAND?

MIRROR
(AT LEAST 15 X 20 CM)

DIGITAL PHOTO CAMERA

PHOTOGRAPHER,
OR SOMEONE WHO TAKES
THE PHOTOS FOR YOU

PRINTER

SUFFICIENT LIGHT

SEEING THE WORLD FROM A DIFFERENT ANGLE

Go exploring, taking a mirror with you. Roam through alleys, a park or woodland, the zoo, a museum, or a garden. Use the mirror to discover new viewpoints you can use to photograph the place.

· Observe the place. Explore, notice details. It's not unusual to spend fifteen minutes simply looking at your surroundings.

· What particular details catch your eye? The petals of a flower, a swing, or the shoes of the man sitting on a bench?

· Explore the place with your mirror. Twist it, turn it, hold it at an angle. Which viewpoint gives you a new, surprising image?

· Now give your photographer instructions: which angle do you want to photograph the place from? Together, decide what works best.

· Look at the photos together. Pick the best one. Why is it the best? What's the most appropriate title?

TIP *"You can take the mirror out with you into the street and give it to a random passerby. Ask them if they'd like to help you to take a photo. Alternatively, you can take the photo by yourself – hold the camera in one hand and the mirror in the other, or lean the mirror against something."*

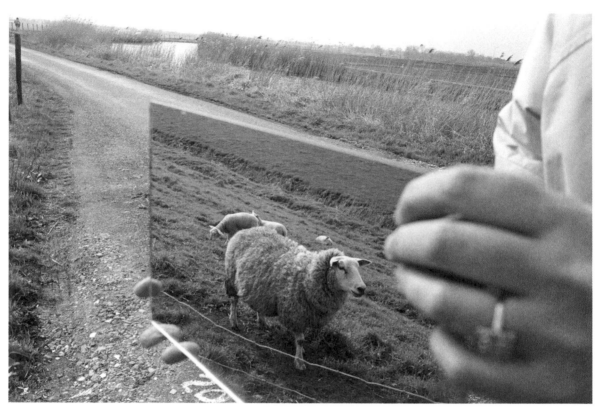

Caught, 2006

MIRROR, MIRROR IN THE HAND, WHO CAPTURES THE BEST IMAGE OF THE LAND?

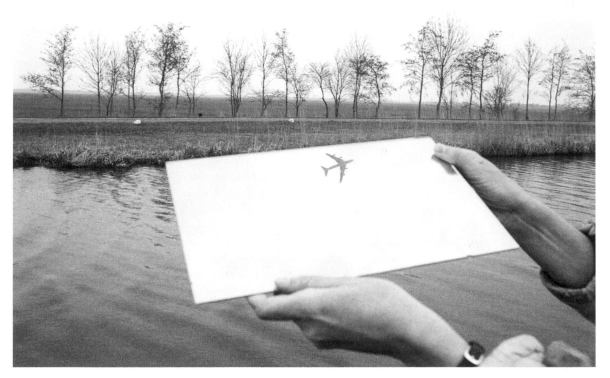

Take Off, 2005

MARIJKE VAN WARMERDAM A hat floats above a ravine, a boy balances a football on his head, and a girl does a handsstand against a wall. Marijke van Warmerdam looks at the world around her and records images from everyday life with a film camera, a photo camera, and sometimes a mirror. The mirror helps her to find unexpected viewpoints. This is how she zooms in on a slice of reality and captures it in photos. And suddenly, a mundane image becomes something quite different.

– PIET OUDOLF AND JOB SCHROËN –

SHALL WE GO GUERRILLA GARDENING?

WHAT YOU NEED

GARDEN TOOLS: SPADE, GARDEN
SHEARS, GARDENING GLOVES,
WATERING CAN, COMPOST

PAVEMENT CHALK TO DRAW YOUR
PLAN OUT ON THE PAVEMENT

YOU CAN OFTEN HAVE LARGE OR
HEAVY ITEMS LIKE COMPOST,
SAND, AND PAVING DELIVERED

LITTLE STICKS AND WIRE
TO MAKE A FENCE. THIS WILL
PROTECT YOUNG PLANTS FROM
DOGS AND CATS

PLANTERS (NOT ESSENTIAL)

MAKE SURE THEY HAVE HOLES IN
THE BOTTOM, OTHERWISE THE WATER
WON'T DRAIN AND YOUR PLANTS WILL
DROWN! YOU CAN ALSO GROW
PLANTS IN OLD BOOTS, BUCKETS,
OR USED SOUP CANS

PLANTS

READ PIET'S AND JOB'S TIPS

FOR THE PAVING: RUBBER
HAMMER, SAND, SPIRIT LEVEL,
STRING TO MAKE STRAIGHT LINES

YOU MAY NEED EDGING IF YOU'RE
MAKING A STREET GARDEN. THE
EDGING WILL HELP TO KEEP THE
PAVING IN PLACE. IT WILL ALSO
STOP LITTER FROM GETTING
AMONG THE PLANTS, AND MAKE
SURE PEOPLE DON'T WALK ON THEM

WILD GARDENING

Go outside and look for a forgotten patch of earth. Where's the best place to make a little garden? Explore your schoolyard or the roundabout on the corner and look at the soil around the trees in your street. If you like, you can make a little garden on the pavement, at the bottom of your wall. But remember: you won't get much rainwater there. Another idea is to grow things in planters. And if you're feeling brave, dig out a pavement tile and make a little garden there.

· See if you can get your neighbors, classmates, or family members involved. Wild gardening's always more fun together.

· Get ideas by visiting a botanical garden. Or a greenhouse. Or a little nursery in your neighborhood. Or get inspired by organizing a tour of gardens and balconies along with your neighbors.

· Decision time. Which plants have you picked? When you're choosing plants, think about interesting mixtures of colors and shapes. Take a few risks and go for a wild, spontaneous garden – we've already got so many neat green spaces. Mix tall and low plants and experiment with differently shaped leaves and flowers.

→

· Pick a good moment. Will you plant your garden in secret by the dead of night – or whistling loudly in broad daylight? Spring is the best time for planting most plants. So get them into the ground in early spring.

· Round up your team, get everything ready, and roll up your sleeves. Dig up the ground, get rid of the weeds, and plant your plants according to the plan you've designed. Take "before" and "after" photos so you can look back on the changes with pride. Have you spotted other forgotten patches of ground? Fill them with a couple of annuals. Put the names of the plants alongside. You never know, you might just inspire someone else.

· Finished? Time to celebrate. Throw a party for your street or your class, or sit out in the sun with a cupcake!

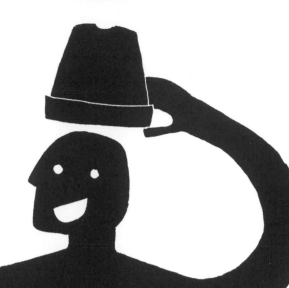

JOB'S TIP

"Think about how you'd like to use the plants. Are you making a hidden garden with a patio in the center, trying to hide cars behind a screen of foliage, or creating a place for kids to play? Laying a path between the plants is handy for gardening and harvesting vegetables, but it also makes a fun place for children to play, or a romantic spot with a little table and chairs to enjoy a glass of wine. You could make the path from gravel, bricks, tiles, shells, or wood chippings – each material has a different feel. What about lighting to prolong the evening? Try out a lamp first to see what kind of light it gives. Many local councils encourage people to create little gardens in the soil at the base of a tree in their street. Find out what you can do in your street!"

PIET'S TIPS

"Choose plants that look pretty – then people will respect them. Like ornamental grass, or a climbing plant. Don't pick ivy because it's boring – it's always green. Hollyhocks or Virginia creepers are a better choice. Or even fruit or vegetables. You could try thornless raspberries, or tomatoes. Carrots have pretty white flowers, too. Some herbs, like rosemary and fennel, are also very attractive. And plant self-sowing biennials. You can keep varying them because they disappear eventually and also tend to have a longer flowering period. Remember that a garden is like a pet– it needs love and care. Gardens need regular weeding and watering. From now on, you'll have to keep an eye on your garden – and that means no more holidays. Unless, of course, you're smart and have a gardening team you can count on."

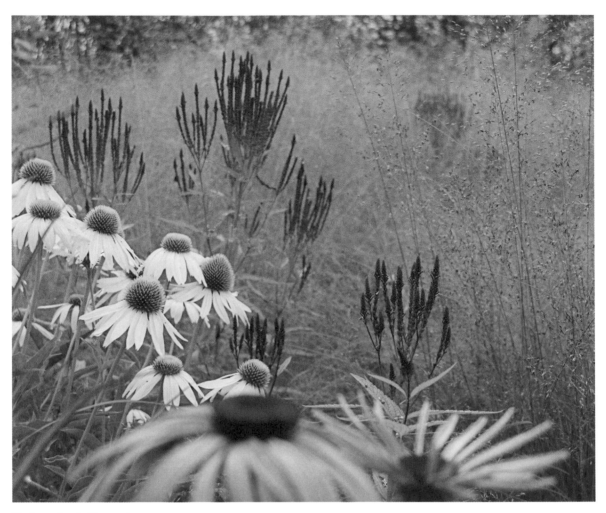

Piet's garden in Hummelo

PIET OUDOLF AND JOB SCHROËN Can you transform your environment? Piet Oudolf and Job Schroën think so. With just a few plants, you can turn your dull city streets into a colorful, wild oasis. You may have heard about Piet Oudolf's wild gardens. One of his masterpieces is the High Line in Manhattan, an elevated rail track that he transformed into a long, lush natural walkway bursting with plants and color. Job Schroën is a resourceful architect and has worked on projects including the futuristic new annex of the Stedelijk Museum Amsterdam. Piet and Job get their best ideas when they work together. So what about transforming your street, school playground, or office? This workshop will show you how.

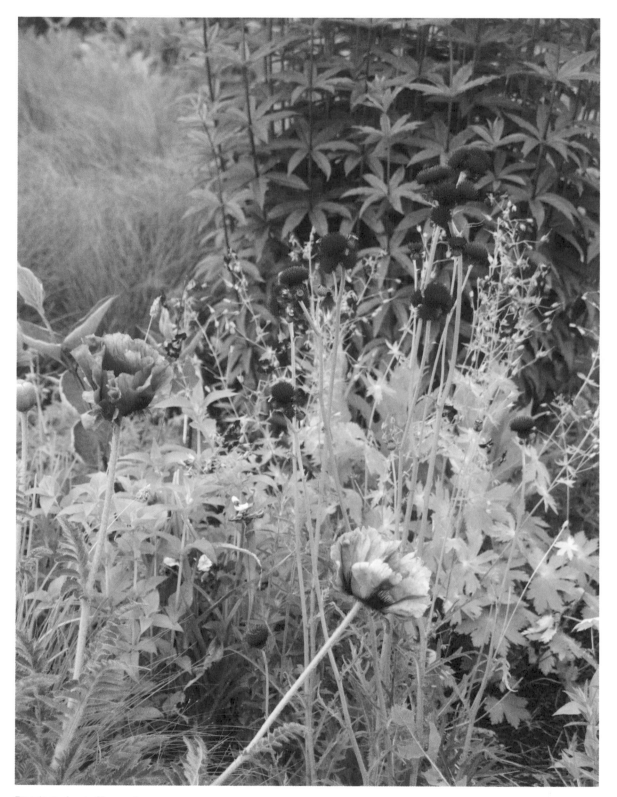

Piets's garden in Hummelo

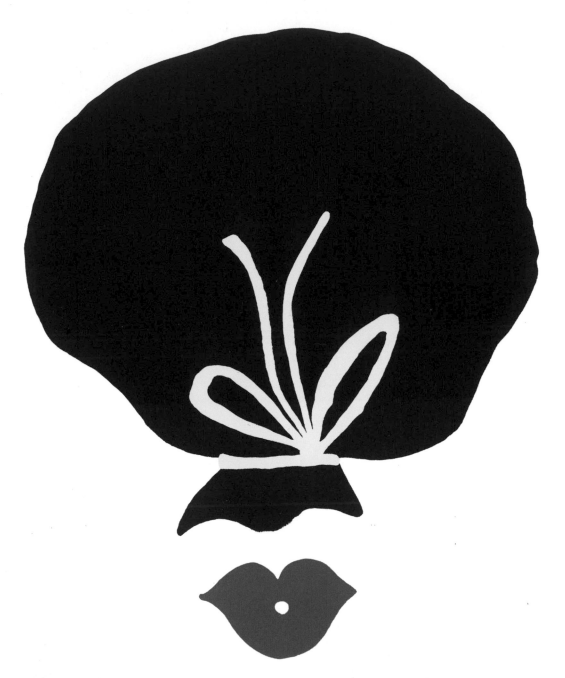

HOW DO YOU TURN A GARBAGE BAG INTO A TAILOR-MADE SUIT?

1 ROLL OF BLACK GARBAGE
BAGS WITH TIE HANDLES

1 ROLL OF TRANSPARENT
ADHESIVE TAPE

SCISSORS

LIPSTICK

EYELINER

ONE HUMAN

MAKE A SUPER CREATIVE OUTFIT
Take a photo and share it with #createwithartists

You can use the ingredients in any way you like. Before starting, you might want to make a sketch of how you'd like your design to turn out. A sketch can be a handy guide while you're making your garment. But if you want to get started without a plan and improvise as you go along, you can!

· When you're thinking creatively, try to be open to different ideas – think outside the box. Is your idea obvious, or fresh and distinctive? Your creation can look like a normal outfit. Or be wild and unconventional – something that's never been done before. Don't tell anyone, but that's our favorite kind of assignment…

· There are lots of questions you can think about: who will I ask to be my model? Do I need a girl to model a dress? Choose someone who is patient and will enjoy being your model – maybe your dad or mom, a friend, or a girlfriend. And you might want to think about how many garbage bags you need to use – one, two, or the entire roll?

· What are you going to do with your garbage bags? You can cut holes in them, turn them into flowers, tape them together, cut out shapes – and lots of other things, of course.

· What is an outfit? Is it a ball gown or a mini dress, a tailored suit or something outrageous? Will you also make your model a hat or jewelry or shoes out of garbage bags? Or will you focus entirely on the garment?

· What can you do with lipstick and eyeliner? You can give your model beautiful red lips, or a red face, or use it to draw a design on the garbage bags.

→

· When you're happy with your design, take a photo of your model wearing your outfit. Share it on social media with the hashtag so everyone can see your design, and you can see other people's creations! Viktor&Rolf: "If someone doesn't like your outfit, they're allowed to say so – everyone's taste is different. Don't take it to heart, because you have your own individual taste and style. But it's nice when people compliment your outfit".

TIP

"Treat your model nicely. He or she is helping you out. Ask him or her if they'd like a drink, or need to take a break. If your model's moving a bit too much, you can ask him or her to sit still so it's easier for you to work. And when you're finished don't forget to thank your model for his or her time!"

VIKTOR&ROLF Fashion designers, artists, businessman...Viktor&Rolf are all these things. Viktor Horsting and Rolf Snoeren became overnight fashion sensations with their first haute couture collection in 1998. Their bold designs are quite magical. For the winter of 2015, they created a wearable art collection. With the baroque gilt frame and strips of canvas around their neck, the paintings look as if they've been broken over the heads of the models, then crushed by a bulldozer. By contrasting and layering elements, and magnifying and reversing details, Viktor&Rolf play with what is art and what is fashion. It gives their designs, from clothing to perfume, an exciting and playful touch. A garbage bag is an elegant tailored suit, is a garbage bag, is a tailored suit.

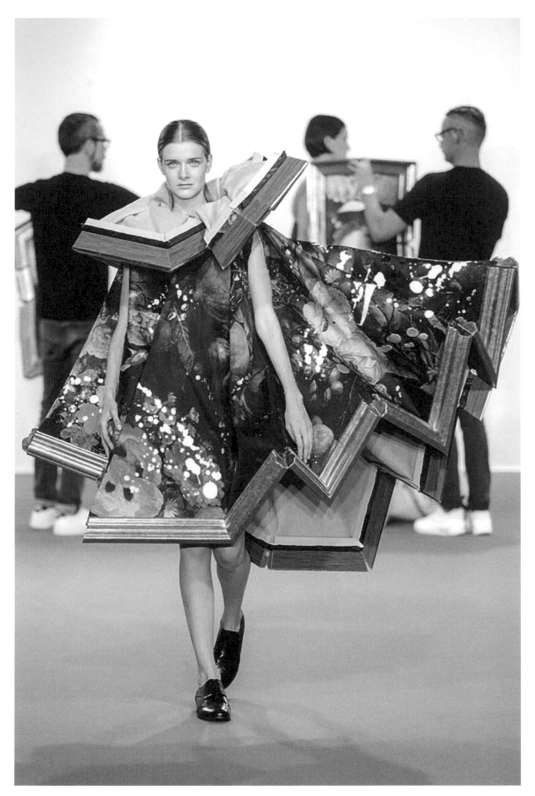

Fall/Winter 2015 haute couture collection

– JOHANNES SCHWARTZ –

WHAT DOES THE BEAR EAT?

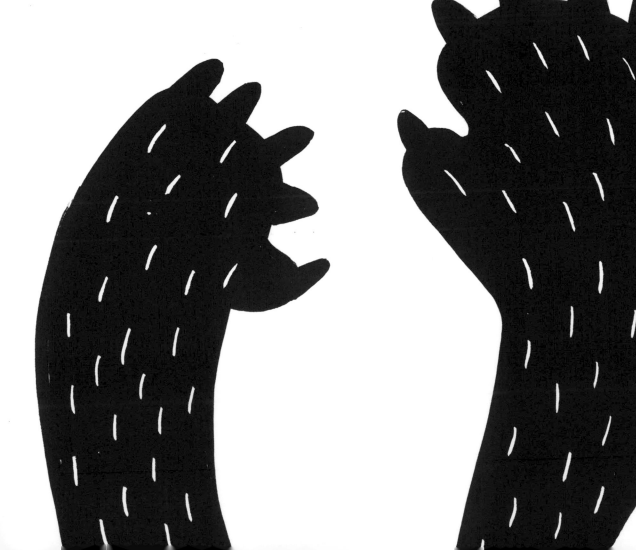

WHAT YOU NEED

MAGAZINES AND
OLD NEWSPAPERS

A LARGE PLATE OR DISH

OPTIONAL:
CHOPPING BOARD AND KNIVES

PHOTO CAMERA

GATHER TOGETHER NASTY AS
WELL AS TASTY INGREDIENTS.

YOU CAN TRY THIS WITH A GROUP
OF FRIENDS, TOO - THREE TO FIVE
PEOPLE WORKS BEST. THAT WAY YOU
CAN WORK TOGETHER WITHOUT THE
RESULT GETTING TOO MESSY

IMPORTANT: THE VARIOUS INGREDIENTS
OF YOUR RECIPE CAN INCLUDE ENTIRE
MEALS (LIKE STEW, FOR IN-STANCE)
AS WELL AS SEPARATE INGREDIENTS
LIKE CARROTS

COOKING FOR AN ANIMAL

What would you serve a polar bear, or perhaps a kangaroo? Make it and photograph it in this workshop. Which animal are you going to cook for?

Think up a description that fits your chosen animal. Maybe "lucky lion," "nervous stray dog," or "hungry hippo" – something that fires your imagination. Look through the magazines and newspapers to find the words that describe the animal. Write them down or cut them out.

· Now that you've chosen an animal, and a phrase to describe it, start preparing your meal. Collect the ingredients for your animal or write them down in a recipe.

→

· Chop, break, and tear the ingredients into small pieces. This turns the horrible ingredients into part of a new recipe, and the difference between nasty and good disappears.

· Next, arrange your meal decoratively on the plate. This is fun, because you see the results straight away. Make a pattern or "composition" of separate ingredients on a plate.

· Now, you're going to photograph the meal. Place the words that apply to your animal next to the plate, and photograph it so that it looks like a real recipe illustration.

· Give everyone a print or send them the digital file so they can print it out themselves.

SEE HOW MOUTHWATERING IT LOOKS!
DO YOU THINK YOUR ANIMAL WILL GOBBLE IT UP RIGHT AWAY?

 TIP *"If you like, you can change the order. See what you can find in the fridge, and lay the food out on the table. Now, imagine what kind of animal might eat it. Draw the animal and tape the picture, along with the animal's nickname, on the fridge. Or hide the animal among the food in the fridge, and shock your housemates."*

JOHANNES SCHWARTZ What is the relationship between people and "wild" animals? This is the kind of question that Johannes Schwartz likes to investigate. He's often called photography's "mine-worker." He photographed the food given to animals in the Moscow Zoo in enormous detail – slabs of fish, chunks of bread, raw meat, and heaps of vegetables. All food we're all familiar with, but clearly not intended for human consumption. Johannes' *Tiergarten* series looks at our astonishing ideas about animals, and also zeroes in on emotions like fear and hope.

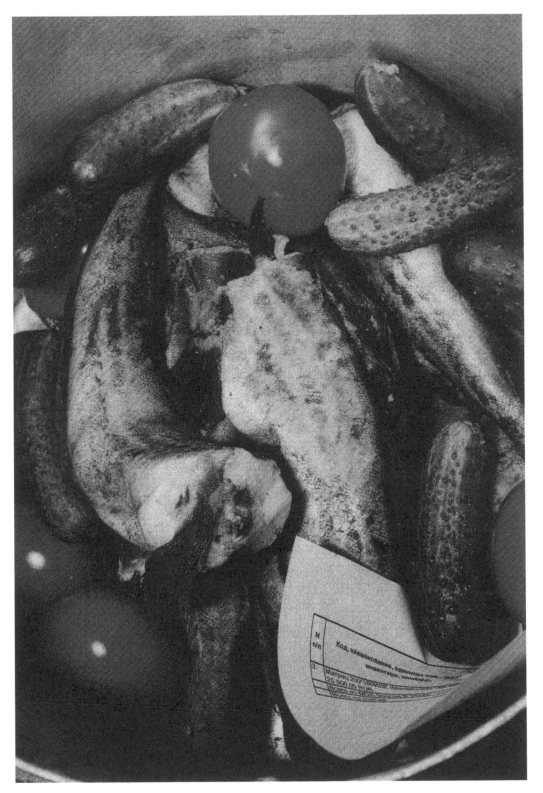

From the *Tiergarten* series, 2014

WHAT FLAVOR IS YOUR SCARF?

WHAT YOU NEED

A PIECE OF SILK OR FINE COTTON
(IT'S BEST TO USE
A LIGHT COLOR)

FABRIC DYE, FABRIC CRAYONS,
OR FABRIC MARKERS
(OR ALL THREE)

PENCIL AND PAPER

MASKING TAPE

TAILORING SCISSORS

IRON

NEEDLE AND THREAD

⊚ TIP *"You always get new ideas while you're in the making process. Little by little, your design grows and starts to take shape. But accidents can happen. The dye might tip over, your marker might slip, or you might cut the fabric crooked. But mistakes often give you incredible, unexpected gifts. So let them happen. And good luck!"*

MAKING A SCARF

What inspires you? Are you like Klaartje, and get your best ideas from the objects and pictures around you? From looking through a photo album or flipping through the pics on your phone? Or do you get the creative urge when you're walking through fields or forests? Don't worry – all your ideas are within reach. Root through your memories or start looking at things around you.

· Let the images flow as you begin to sketch your scarf design. Are you making a pattern? Will you make a neat drawing or get playful and make paint spatters? Will your scarf be colorful or more neutral? Think about the shape you'd like your scarf to be, and keep it in mind throughout your creative process. Because you're soon going to be wearing your amazing wearable painting or drawing around your neck!

· Set out your fabric and paint, crayons, or markers, and get your design sketch. Using the masking tape, tape your fabric onto the table to keep it in place. Important: dyes and markers might stain the table, so cover it before you begin.

→

· Don't think too long – just get started. If you get stuck halfway, then brainstorm new ideas! Get a book from the bookcase or stare out of the window. The most important thing is to keep going. Every line you draw will lead you to your next creative step.

· Now to finish your scarf. What are you going to do with the edges? You can leave them as they are, pull the threads to make them even more frayed, or hem them. What suits your scarf? And don't forget to iron the fabric, because that will help to keep your design look good longer. Done? Wrap it around your neck and take a look in the mirror. What do you think?

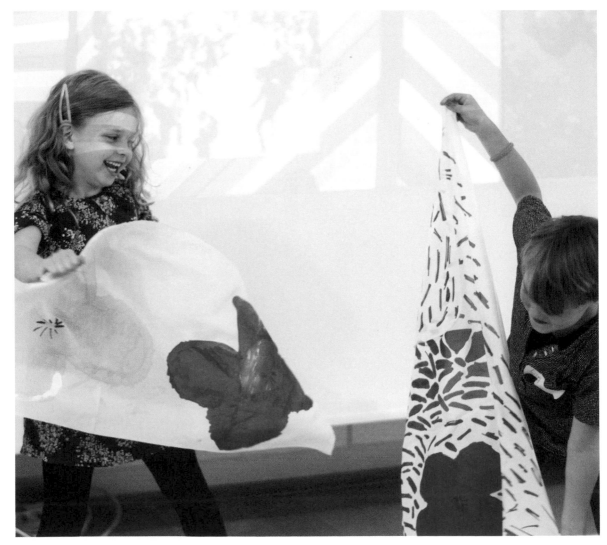

During Klaartje's workshop at the Stedelijk Museum

Klaartje with one of her scarves

KLAARTJE MARTENS loves looking at the world and discovering new things. Her scarves are inspired by the images she's surrounded by: her home is full of books, magazines, fabrics, and a collection of vases. Every design is a puzzle, a case of putting images side by side, combining colors, and creating shapes. And what she loves most is seeing whether all those individual elements can somehow fit together. Klaartje compares it to cooking – it's all about experimenting, putting flavors together to create a mouthwatering dish.

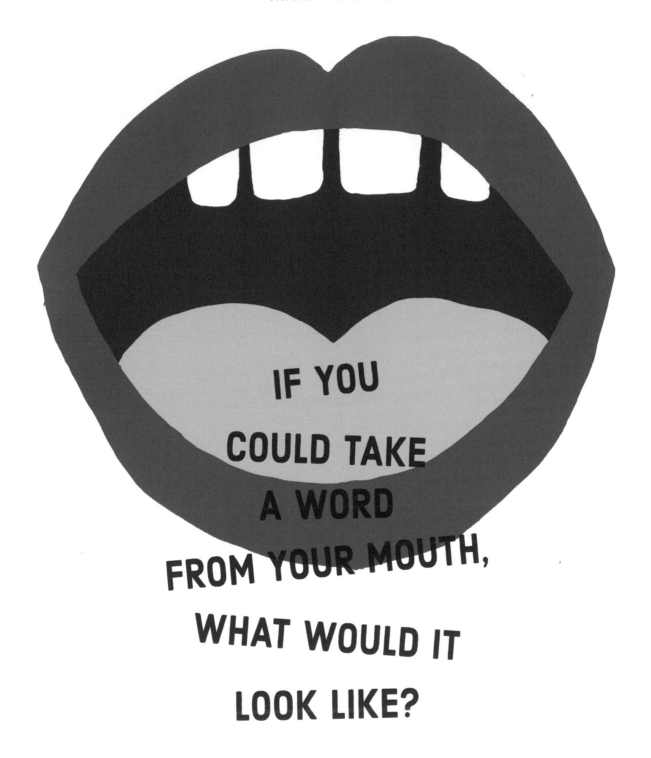

AT LEAST 2 WORDS THAT MEAN
A GREAT DEAL TO YOU
(1 WORD FOR EACH WORD SHAPE)

1 CUP OF SALT
3 CUPS OF WHITE FLOUR

1 CUP OF WATER

A MIXING BOWL

OVEN

PAPER & PENCIL

BAKING PAPER

MAKING WORD SHAPES

Think about something you long for. And something you fear. Write down the words that describe them. You can use as many words as you like as long as they mean something to you. The words need to have a special significance.

· Knead the flour, water, and salt into balls the size of plums. Too sticky? Then add a bit more flour. Too dry? Add a little more water.

· Pop one of the dough balls into your mouth (watch out, it's very salty) and, with a full mouth, say your first word.

· You've just made a word shape. Take the dough ball carefully out of your mouth. Can you see the shape of the word in the dough? Place the word shape on baking paper in the oven: gas mark 170 degrees, 20 minutes.

· Spend those twenty minutes thinking about your word. Write the word down. You can write or draw about what comes into your head.

TIP *"Did you choose a word for something you'd rather be rid of? If so, feel free to crush or throw away your word shape. I once made a series of word shapes of everything that scares me. I'm not sure where the best place is for these word shapes. Maybe Salto Angel in Venezuela, the highest waterfall in the world, would be a great place to fling them all into."*

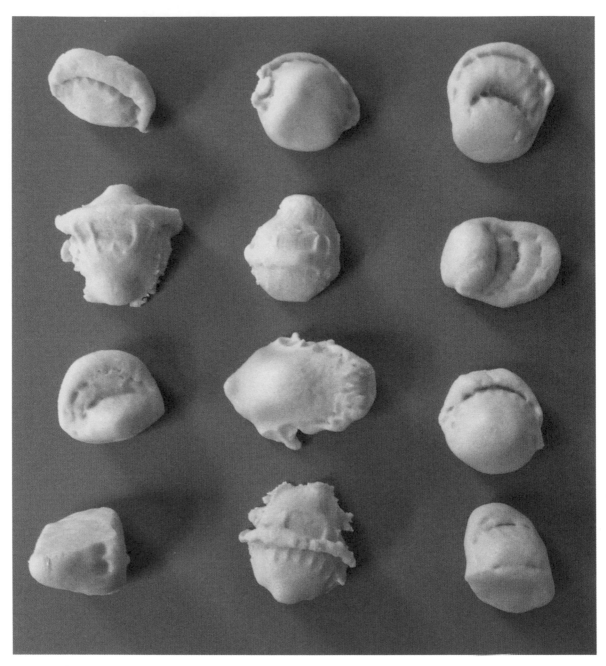

The Things I Should Have Said, 2013

IF YOU COULD TAKE A WORD FROM YOUR MOUTH, WHAT WOULD IT LOOK LIKE?

Yeah-Yeah The Big Bang

Yeah-yeah the Big Bang I hear myself say.
How is it possible that this fits in my mouth?
The origin of everything a lump on my tongue.

Quiet. Fear is a flock that rests in a tree.
Or are these words that cluster together
ink-black on the branches. It is an image

of panic that wells up in me and like a rising
flock breaks out of my throat. The universe
spreads its wings. We flap and emit a shrill cry.

Poem by Maria Barnas, 2013

MARIA BARNAS is an artist, writer, and poet. She is passionate about words and images, description and reality. How do the things around us and the words we use to describe them relate? Does a word in your head change the minute you say it aloud? Is the word "apple" the same as the apple in your hand that you can take a bite from? Word bites don't answer these questions. And the words that come from your mouth – the word shapes – almost always ask questions.

CAN YOU CREATE A
UNIQUE DESIGN IN 1 MINUTE?

EASY TO MODEL,
SELF-DRYING CLAY

A STOPWATCH OR KITCHEN TIMER

ACRYLIC PAINT + WATER
TO THIN IT DOWNN

BRUSHES

ONE MINUTE

UNIQUE IN CLAY

Ready, set, go!

· Take a piece of clay and knead it for a while. Close your eyes: what do you feel?

· Put the clay down and look at it. Can you see a shape starting to develop? Experiment with the shape by kneading the air. Have you found your shape? Great – then you're ready to begin.

· Pick up the piece of clay and set your timer: you've got one minute.

· When the minute's up, put your design down in front of you. And? Does it look like a vase or is it more of a squishy shape?

· Get a fresh piece of clay and repeat the one-minute-method one or two more times. Which vase is your favorite (or, as Marcel calls it, your "lucky one")? And why? What title will you give it?

· When the clay has hardened, you can paint your vase using the acrylic paint. Marcel loves gold best. What color do you think is right for your creation?

TIP *"Make it more difficult by setting the timer for 20 seconds. Try closing your eyes or only using your left hand. Or make something with a friend. Or without using your fingers. There are lots of ways to use the one-minute-method. I've also made One Minute Delft Blue vases and plates. Would you like to do it, too? Go to a secondhand storé and find a white ceramic object. If you can, choose one with an unusual shape. Get some blue acrylic, glass, or ceramic paint. Don't start painting yet – practice first by painting in the air. Now set the timer and go! In just one minute, you can paint your own, unique Delft Blue design."*

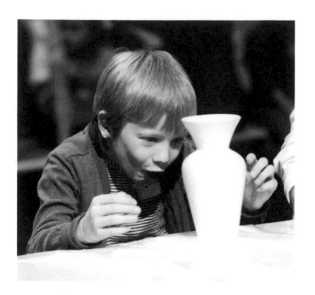
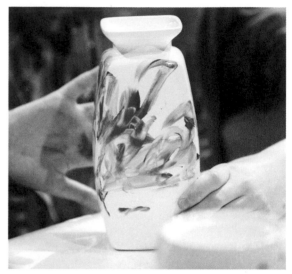
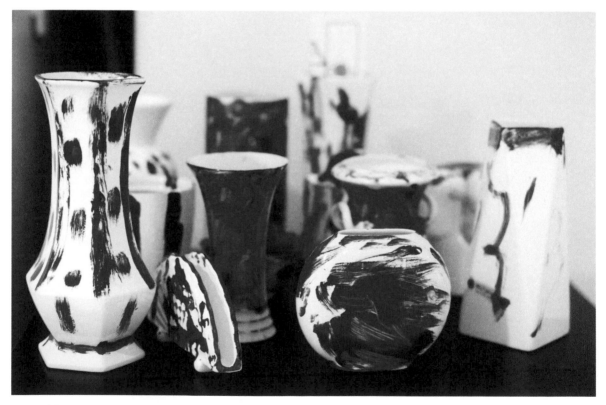

During Marcel's workshop at the Stedelijk Museum

CAN YOU CREATE A UNIQUE DESIGN IN 1 MINUTE?

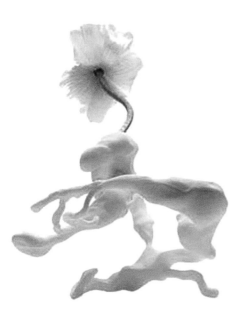

Airborne Snotty Vase Coryza, 2001

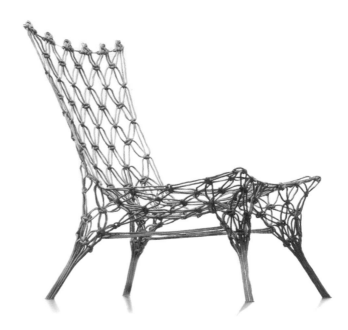

Knotted Chair, 1995-96

MARCEL WANDERS Can you make a vase in a minute? Marcel Wanders, the famous designer, did this very thing for his "One Minute Sculptures." You might know Marcel's chair made out of knotted twine, or his "snotty" vases. For Marcel, a design doesn't always need to serve a function – emotion and spontaneity are important, too. And uniqueness. Ready for Marcel's one-minute-method?

HOW TO MAKE A VERY SPECIFIC OBJECT THAT HAS NO SPECIFIC FORM?

HOW TO MAKE A VERY SPECIFIC OBJECT THAT HAS NO SPECIFIC FORM ?

ALL ART IS MADE BY PEOPLE TO PRESENT SOMETHING TO OTHER PEOPLE ABOUT THE RELATIONSHIPS OF OBJECTS IN RELATION TO HUMAN BEINGS
ALL MEANS OF PRESENTATION (PAINTING · SCULPTURE · TEXT · GESTURE) HAVE THE SAME VALUE
I HAVE FOUND THAT USING LANGUAGE TO PRESENT THE RELATIONSHIP OF STONE TO WOOD ALLOWS THE RECEIVER TO USE THEIR OWN PERCEPTION
OF STONE & WOOD TO BUILD AN UNDERSTANDING OF WHAT IS PRESENTED TO THEM

WHAT YOU NEED

1. SOMETHING YOU WANT TO SHOW SOMEONE
2. AN INTEREST IN THE MATERIALS THAT MAKE UP OUR WORLD WITHOUT HIERARCHY
 GOLD IS AS USEFUL AS CHEWING GUM
3. YOUR OWN NEEDS & DESIRES AS TO HOW THINGS SHOULD LOOK

A TRANSLATION FROM ONE LANGUAGE TO ANOTHER

LAWRENCE WEINER says art makes us reconsider our place under the sun. To him, the essence of a work of art lies in words, not in paper, wood, or paint. For this book he specially made a work you can use yourself. You can translate it into something physical. You can also choose not to. You can turn it into something textual. Or you can also choose not to.

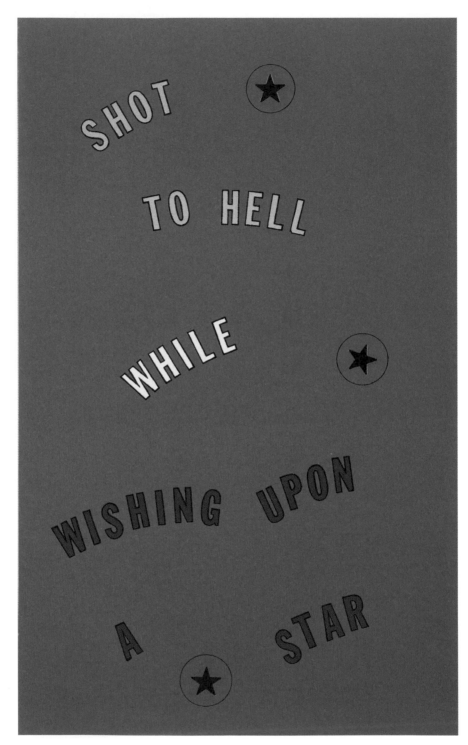

SHOT TO HELL..., 1995

HOW TO MAKE A VERY SPECIFIC OBJECT THAT HAS NO SPECIFIC FORM?

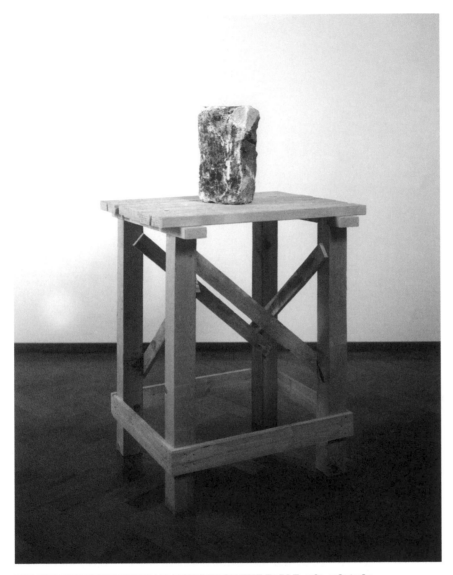

WHAT IS SET UPON THE TABLE SITS UPON THE TABLE, 1960-1962/1982,

HOW DO YOU MAKE A WEARABLE SPACE VEHICLE?

WHAT YOU NEED

METAL WIRE COPPER OR STEEL

STRING, CABLE OR BAND,
RUBBER BANDS

HERE ARE SOME TOOLS YOU
MIGHT NEED TO WORK YOUR
MATERIALS:

FRETSAW

DRILL

A HUGE COLLECTION
OF PLASTIC

HAMMER

COLORED TAPE

FINE SANDPAPER AND FILE

SCISSORS

A GLUE GUN WITH GLUE
CARTRIDGES (YOU CAN USE
COLORED ONES IF YOU LIKE)

PLIERS

MAKING YOUR NECKLACE

Over the years, Jantje has gathered a huge collection of plastic. And before that, she collected metal objects. Which material will you choose? Starting now, collect everything you find in your chosen material. Ask friends and family to help. The bigger your selection, the more exciting combinations you'll be able to make.

You're going to be an artist, engineer, and inventor all rolled into one. We'll launch into space with the necklace you've created. So what kind of vehicle do you need to make your journey?

Ready to make a rocket ship you can wear on your space odyssey? 3, 2, 1…liftoff!

· Lay out the materials you've gathered. Organize them according to shape, color, or size. Which colors go together and which shapes remind you of something, or can be combined? And what kind of trip do you want to make? Important: you'll soon be wearing your space craft and your story around your neck. So choose the best pieces of your collection to build your rocket ship.

→

· Now that you've picked out the best pieces in your collection, it's time to play. Which ones look best together? And how are going to fix the different parts together (or attach them to the chain)? Do you need to saw, drill or file your materials?

· What kind of necklace are you going to make? One with objects strung together like a beaded necklace, or will your design be more like a pendant hanging from a chain? Maybe your necklace will show the route your spaceship's going to take. Will it be a long, wild journey or over in a nanosecond?

· Imagine the journey ahead! Now start gluing, binding, and sticking. You can cover up the joints, or use the colored tape or glitter glue as part of your creation.

Look at your design from every angle. Is it finished now? Or could your intergalactic journey use a few more important odds and ends from your collection?

IS THE NECKLACE FOR SOMEONE ELSE? THEN DON'T FORGET TO SHARE YOUR SPACE TRAVEL ADVENTURE. SHOW IT OFF!

TIP

"Look at the moon at night or visit the planetarium. Dream of a journey to distant planets while you're lying in bed or sitting at the kitchen table. Anything's possible. Think the most impossible thoughts. A vivid imagination is a fantastic basis for creating amazing things."

JANTJE FLEISCHHUT designs jewelry. She mixes gold with bright colored plastic. Which is an odd combination, but it works really well. She also loves spaceships and the moon. She used to be a big *Star Trek* fan, and loved the adventures in *The Little Prince*, a book about a little boy who discovers the planets of the universe. Jantje collects plastic for her designs, which she stores in a huge cabinet in her studio. Every drawer is crowded with things. Yellow with yellow, red with red...and so on. And they're all launching pads for a journey through stories from throughout the universe.

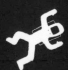

To Be in Orbit, 2011

HOW DO YOU TURN YOUR NAME INTO A TAG?

A BOOK WITH A BLACK COVER
AND BLANK PAGES
(YOUR BLACK BOOK)

MARKERS,
BUT NOT JUST ORDINARY FELT
PENS. YOU'LL NEED
MARKER PENS: PENS WITH BLACK
PERMANENT INK IN DIFFERENT
THICKNESSES, PAINT MARKERS
(LIKE SILVER INK MARKERS),
DESIGNER MARKERS

PENCIL, ERASER, AND
BLACK FINELINER

RULER

GET TAGGING

A graffiti artist always carries their black book wherever they go. So when an idea pops into your head, make a quick sketch. Use your black book to experiment with the letters of your name – fill your book with tags!

· Before you start experimenting with letters, you need to understand them. Start with the basics – what is a letter made out of? An **M** for instance, is composed of four separate lines: |ıı|. Write down each of the letters in your name separately.

· Now write your name in full. Each time you write it, make one change to each letter. Add a curl to the "M," or draw arrows at the ends. Experiment with different modifications. Use different pens. The more you practice, the better.

· Now go a step further: what if you turn the letters around? Or stretch them? Or tip them over? Or make all the letters overlap? Have fun and distort them – turn them into skinny letters, into big fat letters – play with them.

· Now for something totally different: write your tag out, then cut out details and use them to make a totally new, different tag. Do whatever feels right – it doesn't need to be legible or look perfect. Do you like the way the lines look? Then color in the shapes, go over the contour lines, or create a shadow effect. Keep practicing.

TIP *"We all follow rules about what letters have to look like so we can understand words and language better. The alphabet we use today dates back to Roman times. So those rules were invented thousands of years ago! Good graffiti artists know these letter rules so well that they can break them. And you can do the same by asking how an "M" needs to look, to still be an "M." Flip the functions of parts of letters. For instance, use the inner line of one letter as part of the outline of another. Pull letters apart like elastic. Turn them upside-down. Spin them around. Or turn the open space in one letter into a different letter. Keep experimenting. I've written my name thousands of times and still find new ways to write it."*

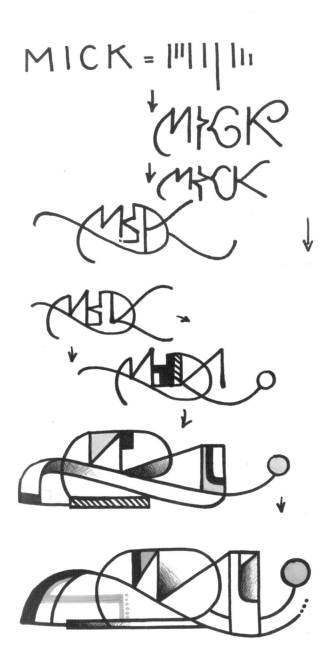

Sketches from Mick La Rock's black book

HOW DO YOU TURN YOUR NAME INTO A TAG?

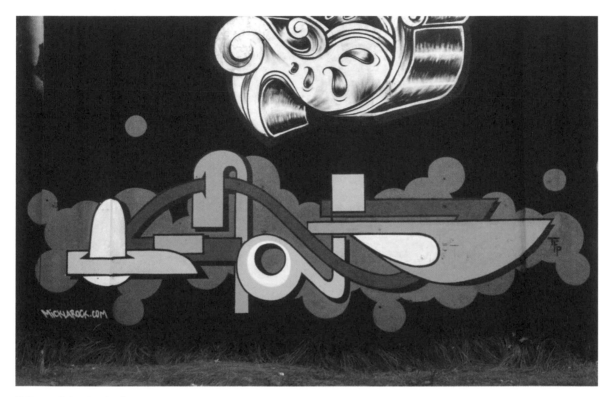

Bellamyplein, Amsterdam, 2012.

MICK LA ROCK The first time she wrote her name in graffiti, Aileen was thirteen years old. Now, she's known as Mick La Rock, one of the world's first woman graffiti artists. Since making her first tag (a graffiti-style signature written fast using spray paint or marker) she's never stopped experimenting with letters. In Mick's tags, letters are abstract shapes created from lines and color. When she designs a tag, she asks, "Does a letter have to be legible?" and "Do the letters have to keep their shape?" And "When is a letter still a letter?" Tag your name and see how far you can go.

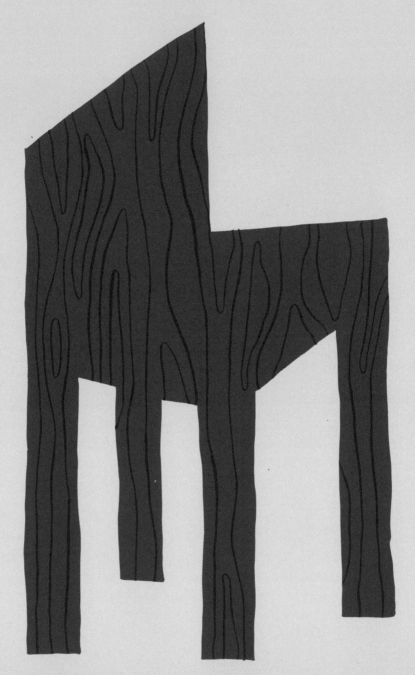

HOW DO YOU MAKE A CHAIR FROM FLAT MATERIALS?

DRAWING PAPER

DIFFERENT TYPES, THICKNESSES,
AND COLORS OF CARDBOARD
(OLD BOXES, FOR INSTANCE)

COLORED PAPER

PENCILS, FELT PENS, ETC.

BOX CUTTER OR SCISSORS

TYPES OF FIXATIVES:
TAPES IN DIFFERENT COLORS,
TIE-WRAPS, GLUE GUNS

MAKING A CHAIR FROM FLAT MATERIALS

An idea that fascinates Ineke Hans is making a chair from a single sheet of material, following in the footsteps of Gerrit Rietveld. How would you go about doing that?

· Decide on who – or what – you'll use as a model to show off your chair. You might choose a person, an old teddy bear, or a wooden painter's dummy.

· Start sketching out your ideas. Think about:
- What your model needs to sit on – a chair back, armrest, a chair seat, legs. What are the lengths, heights, and angles you need?
- How you can make that out of cardboard. Think hard about how to make each section out of a flat piece, and how you'll need to attach them.
- What type of chair is it? A comfortable easy chair, a simple design, or a robust chair?

· Experiment with the materials you have. Find the strongest types of attachments.

· Finished with sketches and experimenting? Now pick the idea that best fits your design, or is the smartest idea you've come up with. Make the chair. Designers call this a prototype; you don't make the actual chair until later. But your model can sit in it right away, of course!

TIP *"First look for inspiration. You might visit a museum, or do an online search if you're at home. A great many designers have thought about ways to make a chair using a sheet of wood or metal. Gerrit Rietveld is one of the best-known. Rietveld also wanted to make affordable furniture for people on a budget. You may have seen his Zig-Zag Chair. Apparently, the wooden board cost around 90 cents. Rietveld also designed a chair made from a single sheet of aluminum with folded edges. That makes the chair incredibly strong. You can make your chair stronger by folding the cardboard, or rolling it into a tube."*

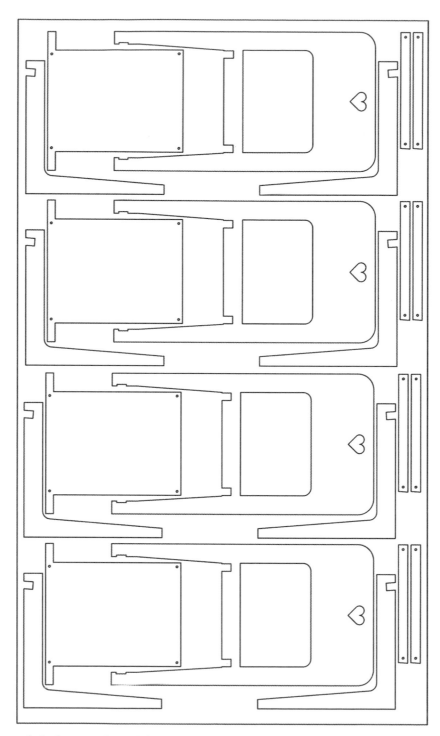

4 chairs from one sheet of plywood

HOW DO YOU MAKE A CHAIR FROM FLAT MATERIALS?

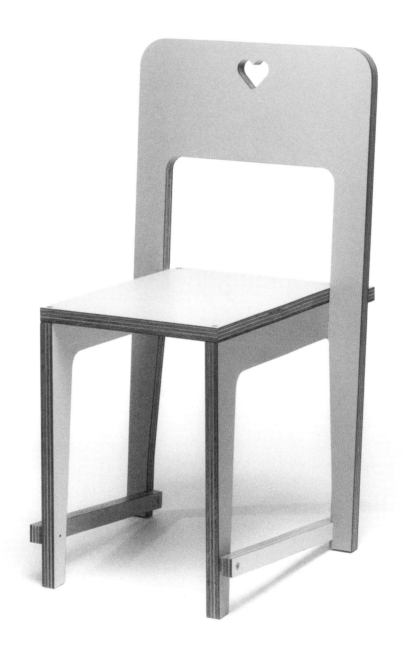

Eat Your Heart Out, 1997

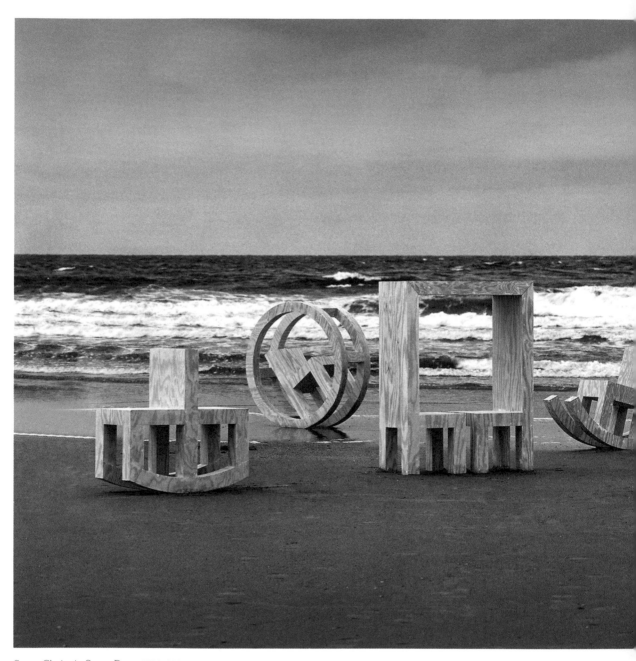

Seven Chairs in Seven Days, 1993 -1995

HOW DO YOU MAKE A CHAIR FROM FLAT MATERIALS?

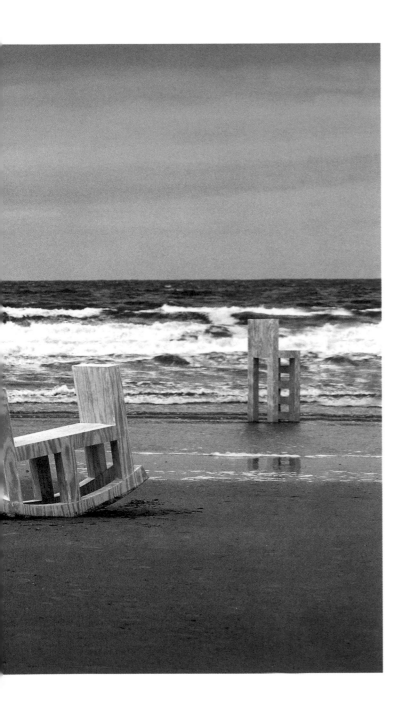

INEKE HANS What exactly is a chair? Ineke Hans likes to answer this question with simple designs. Her chairs often play with most people's idea of a chair. A great example of this is her series *Seven Chairs in Seven Days*. Ineke got the idea quickly and intuitively, and worked out her designs over the next two years, coming up with seven different versions. Chairs that look like a pictogram, but are produced in 3D. They still function like real chairs.

WOULD YOU LIKE TO TAKE THINGS APART AND PUT THEM TOGETHER AGAIN?

A LENGTHY WORKSHOP

The following should be attempted or carried out over a reasonable period of time – between one and three years.

· Remove the engine from a Citroen car produced during the 1970s and replace it with a new engine.

· Make a film of yourself sitting on a wooden chair while destroying the same chair by cutting it up with an electric jigsaw.

· Make a cow out of an office desk.

· Make a man with two arms and no head out of a storage container.

· Paint a picture of the view of the back of your head.

· Make a video of yourself doing a jigsaw puzzle with your feet.

· Sing "Moon River" to a group of people you have only known for a short period of time.

· Make a tree trunk from a large roll of cardboard.

· Try to produce objects that are abstract representations of important people.

· Attempt to make a good artwork incorporating scuba flippers.

· Make a massive painting of the head of a kitten.

· Make a list of all uninhabited islands under the control of the USA.

· Clean and prepare 200 red snapper fish.

· Record an album of songs in a recognizable genre.

→

· Find a smashed electronic object and cast it in bronze.

· Build a large sculpture that mocks tabloid newspapers.

· Produce a series of paintings that focus upon industrial strikes.

· Without resorting to representation produce a psychological portrait of an important and powerful individual.

· Open a bar that only serves Tequila Slammers.

· Read any books in the art library that do not directly relate to or refer to art.

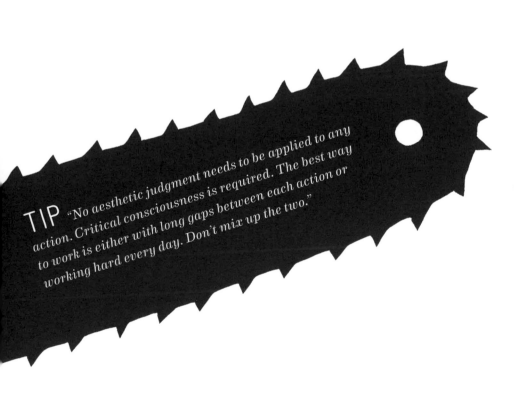

TIP *"No aesthetic judgment needs to be applied to any action. Critical consciousness is required. The best way to work is either with long gaps between each action or working hard every day. Don't mix up the two."*

All-Imitate-Act, Museum Square, Amsterdam, 2015

LIAM GILLICK doesn't use mood boards or walls of inspirational mottos to find ideas. He always begins with an empty table. And he tries to avoid eureka moments. For Liam, art is powerful when it results from a sequence of ideas. And that's a process that might take Liam years. Every morning, he asks himself, "What kind of artist do I want to be today?" He's more interested in questions than answers. Questions such as how people react to art and how art relates to everyday life. Or questions about today's artist – who is he, and is his art better if he's standing next to it? Liam focuses on materials, facts, and specific situations. He often makes art for public places such as parks or city squares. And because passersby can interact with the artwork, his art is always different. It's never finished. Which is perhaps why he created a workshop that you can carry out for years to come.

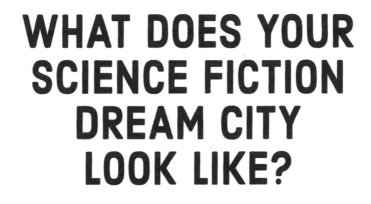

WHAT DOES YOUR SCIENCE FICTION DREAM CITY LOOK LIKE?

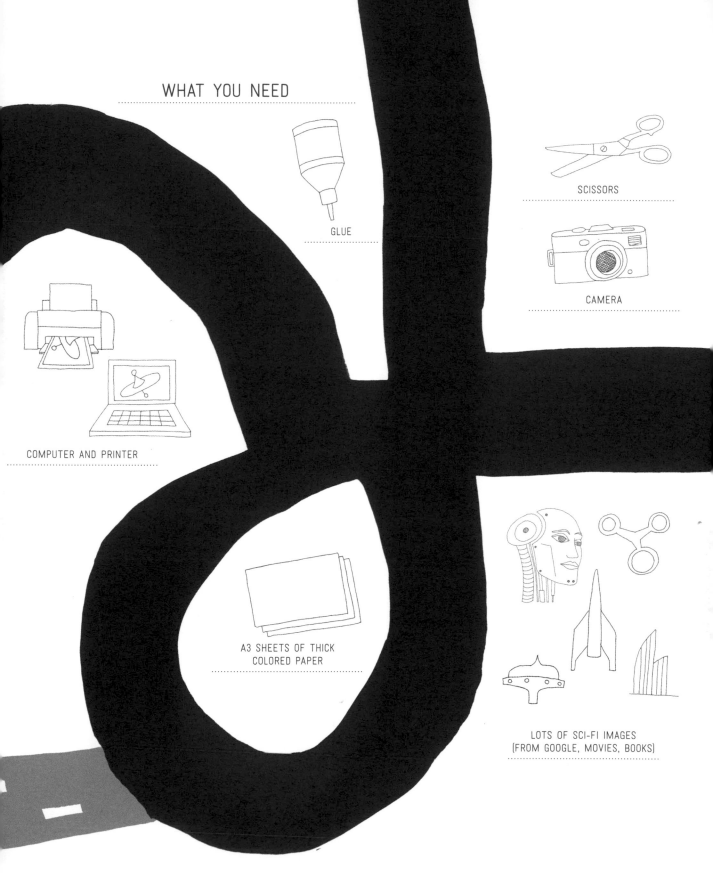

WHAT YOU NEED

GLUE

SCISSORS

CAMERA

COMPUTER AND PRINTER

A3 SHEETS OF THICK
COLORED PAPER

LOTS OF SCI-FI IMAGES
(FROM GOOGLE, MOVIES, BOOKS)

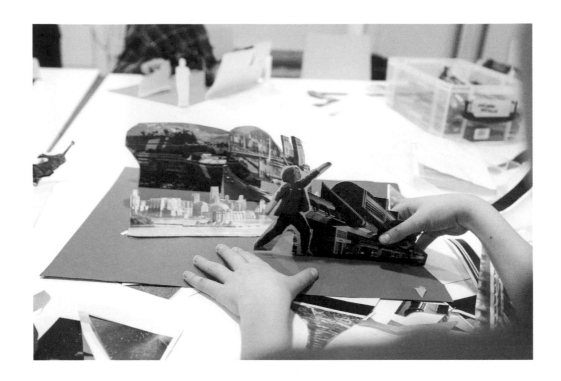

During Persijn and Margit's workshop at the Stedelijk Museum

WHAT DOES YOUR SCIENCE FICTION DREAM CITY LOOK LIKE?

STICKING THE FUTURE TOGETHER

Now...think of your image of the future. What will your city look like fifty years from now? Or even five hundred or five thousand years into the future? Has progress made people happier, or is the world filled with grey, unhappy faces?

Find visual material to fill your city. Google terms like "extra-terrestrial plant," "car of the future," or the title of your favorite sci-fi movie. Print out your favorite images. And make sure to collect a lot of pictures – you need to have plenty to choose from.

Think about your city of the future. First decide which year you're going to pick. Ten years from today? Or a million? Is your city on earth, on a different planet, or in a black hole? Maybe your city's a ruin, overgrown by gigantic forests. Or perhaps the whole world has been turned into a huge highway with buildings that touch the sky, inhabited only by robots or flying unicorns. Or has nothing much changed? Don't forget – anything's possible. Your city can be as big, small, wonderful, or scary as you like.

Now choose the pictures that come closest to how you imagine your city. Place a colored sheet of paper on the table and cut out your buildings, leaving a strip at the bottom (this is how you'll glue your pictures to the paper). Fold the strip horizontally, so that your pictures stand upright on the paper. And experiment! Which buildings go together? Do you need more things for your city – roads, bridges, vehicles, trees? When you're happy with the way your city looks, glue your shapes into place.

Now take a photo of yourself, pretending to be someone from your city. Make a small print of the photo and stick yourself among your buildings. Now your city has an inhabitant. How does it look?

What do you think of your city? Is it a place you'd dream of living in? Or is it more of a nightmare? What kinds of creatures live there? What's your city's name? Design a name board and add it to your city – now your design is finished.

TIP *"While we're working, we always find it helps to go for walks in nature. When you work so much with digital media like us, it's great to walk in the woods, where you find an entire world hiding behind each tree and however much you zoom in and out, there's no end to it. We observe everything, brainstorm, and then get back to our computers with tons of new ideas. And if you get stuck, you can always look out of your window. Take a good look at what's out on the street and use it in your own futuristic city. It doesn't have to be boring. What does a streetlight look like in your world? What kind of bikes are there? Cranes? Fountains? Birds? Cars? Dogs? Dragons? You can find pictures of all kinds of things in Google, too. Search for something, putting 'Science Fiction' or 'Future' first – or do a search in Chinese: 未来之城*

PERSIJN BROERSEN & MARGIT LUKÁCS For their installation *Ruins in Reverse*, Persijn Broersen & Margit Lukács watched every sci-fi movie ever made. They love science fiction because they're fascinated by new technology. They wonder what will happen to human beings – how we'll visualize things, and what our moral values will be – when we're bombarded by a torrent of (digital) images and ideas every day. The two artists work together, making videos, animations, and architectural designs, and they've also designed a carpet and an interactive light wall in a parking garage. What will your city of the future look like if you have a chance to imagine your best- and worst-case scenarios? Persijn and Margit are here with some great ideas.

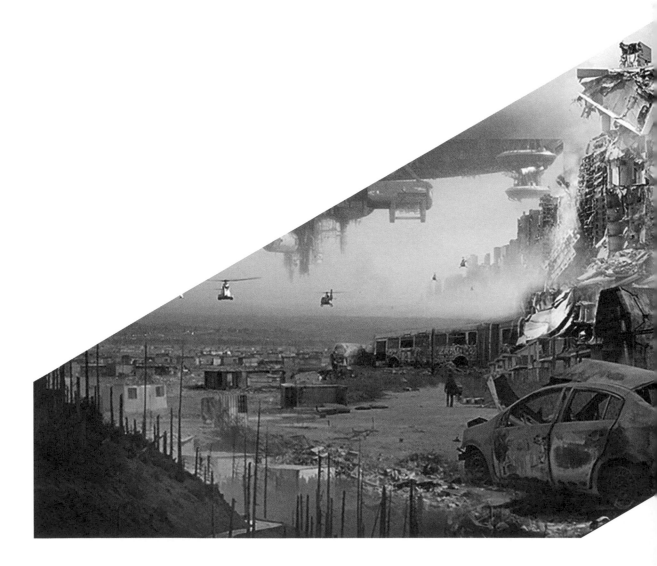

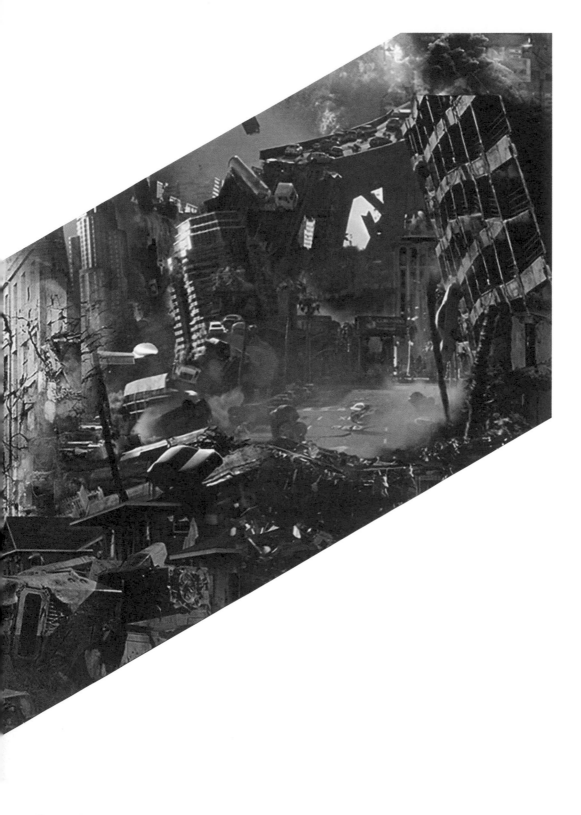

Ruins in Reverse, 2014

– JAN ROTHUIZEN –

CAN YOU DRAW MORE THAN YOU CAN SEE?

THICK SHEETS OF WHITE PAPER,
A3 FORMAT OR LARGER

PENCILS, AN ERASER, PENS OR
SOME OTHER WRITING TOOL FOR
FINE WRITING AND DRAWING

(JAN USES A FOUNTAIN PEN
AND INDIA INK)

PRACTICE

Draw your bedroom – it could be an old room, or the one you have now.

· Close your eyes (shut them tight – that way your imagination works better) and walk through that room. Try to imagine what it looks like and how it feels.

· Start sketching the shape of the room. Are you drawing it like a floorplan, showing a view from above, so you can get everything in? Or do you prefer a different perspective? What does your room look like if you're lying on your bed?

· First, draw the fixed objects like the windows and door. Now add the furniture and hang up the posters.

· Draw or write down things that only you know. The scary corner in your room, or the sounds you hear at night. Draw the things that particular objects remind you of. If you imagine something hiding under your bed, don't forget to include it in your drawing.

NOW FOR REAL

Finished your drawing? Now you're ready to get down to business. Find a place you'd like to find out about. It could be a street you don't know, or your favorite spot in town. Draw and write down what you hear, smell, and see. And make a note of what you think of the place. Does it have a particular atmosphere? Do you ever think about what's happened there? Talk to people to find out more about the place.

Make your first map. This is where you add your impressions (or use Google Maps). Have you uncovered all the mysteries and gathered piles of information? Great. Now make a huge drawing packed with all the information, images, and ideas that you've found.

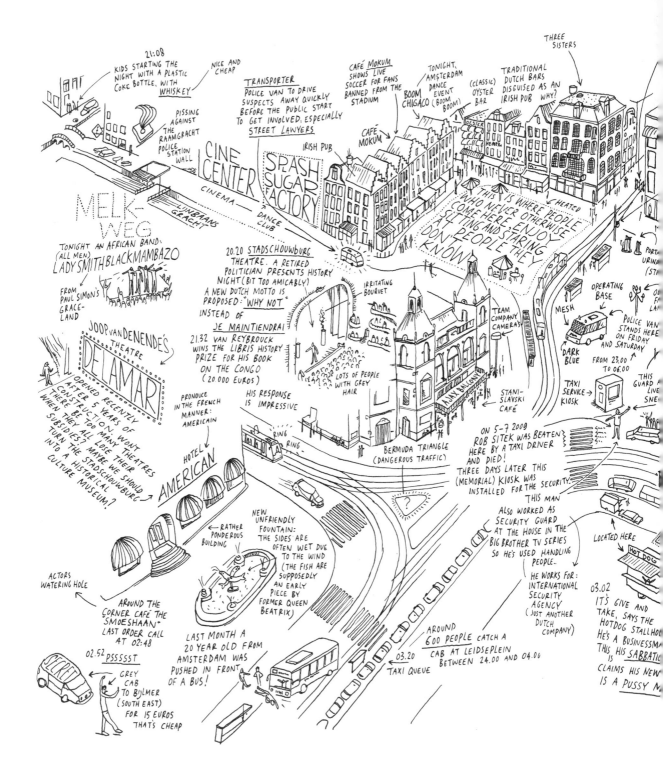

The Leidseplein, 2009

CAN YOU DRAW MORE THAN YOU CAN SEE?

RF PROCASH ATM CAN
KNOTES. GIVEN THE CONSTANT
E THREE ATMs THROUGHOUT
OM 19.00 ON, THE MONEY BEING
NSED MUST RUN INTO HUNDREDS
OF THOUSANDS!

23.24
THE BURGER KING SECURITY GUARD
IS A FEW TEETH SHORT. HE FOUGHT IN
BOSNIA AND DID SOME STREET COACHING
IN AMSTERDAM WEST. (SLOTERMEER)
HE GETS AN ASSISTANT AT 3 O'CLOCK
BECAUSE AFTER THAT EVERYBODY IS DRUNK.

6.5 METERS
HIGH BEER
GLASSES
FILL WITH
LIGHT
(400 NEON
TUBES)

EXTRA COLD!
(RIDICULOUS)

URGER KING

PANCAKE HOUSE
THEY DO PIZZAS TOO

BULLDOG
WORLD
OFFEESHOP

BAR REST.
BLINO

INSIDE IS A
MIXTURE OF
SMOKE AND BEER

THE STAIRS
ARE EXTRA
STEEP WHEN DRUNK

TALL STAIRS TO THE MEMBERS
ONLY CLUB "DE KRING"
(THE CIRCLE)

GABOR (AGE 24, WITH SPECS)
FROM HUNGARY RENTS THIS
RICKSHAW FOR 200 EURO'S A WEEK
ON A GOOD NIGHT (FROM 22.00 TO 06.00)
HE MAKES 150 EURO'S (LOTS OF RIDES
TO THE RED
LIGHT
DISTRICT)

TOURISTS
FOR
TOURISTS

ART-HOUSE
CINEMA

CITY

RANCHO
RED
MEAT

THEATRE
RECENTLY THE BUILDING
HAS BEEN RENOVATED
TO ITS ORIGINAL
SELF

03.20
GUYS
REFUSED
(ONLY REGULARS:
BS)

THEY'RE MOROCCANS BUT
IS IT DISCRIMINATION?

BIKES

MAYOR
EBERHARD VAN
DER LAAN PLANS TO DEPLOY
UNDERCOVER OFFICERS TO FIND OUT...
AND THEN?

VERT

THIS IS THE
ENTERTAINMENT
AREA

PING

PING

SAYS THE
TRAM DRIVER

THIS IS ABN-AMRO
ANK OR
TS LEFT
LOOKS
ORE
SIGN

THE BALIE

HERE
THE CULTURAL
TYPES
CONGREGATE FREE
WI-FI

TAXIS QUEUEING UP

TONIGHT AT PARADISO
KELIS (CURLY HAIR)
(OF: I HATE YOU SO MUCH
AND MILKSHAKE
FAME

TIP *"Draw what you can't describe and describe what you can't draw. Don't be frustrated if it turns out differently from what you'd expected. Stay in a place longer (much longer) than you'd usually do, and talk to everyone! Tell them stuff about yourself. That's how you gain their confidence. And it helps if you say you're an artist (then you won't seem so scary!). Everything that happens is part of your drawing – and use the things that go wrong, too! You can also get ideas from floorplans used by the fire department. They hang almost everywhere."*

JAN ROTHUIZEN loves taking to the streets and drawing what he sees. He'd rather be outside than sitting at his easel, painting in his studio. Jan's drawings show what he hears and thinks about when encountering stories on his walks. This is how he makes his soft maps. You can't use Jan's maps to find your way around. They encourage you to drift, along with Jan. His maps give you a glimpse of the beauty and hidden stories of a supermarket, city, or busy museum. Every map reveals the way that Jan, as an artist, sees and explores the world around him.

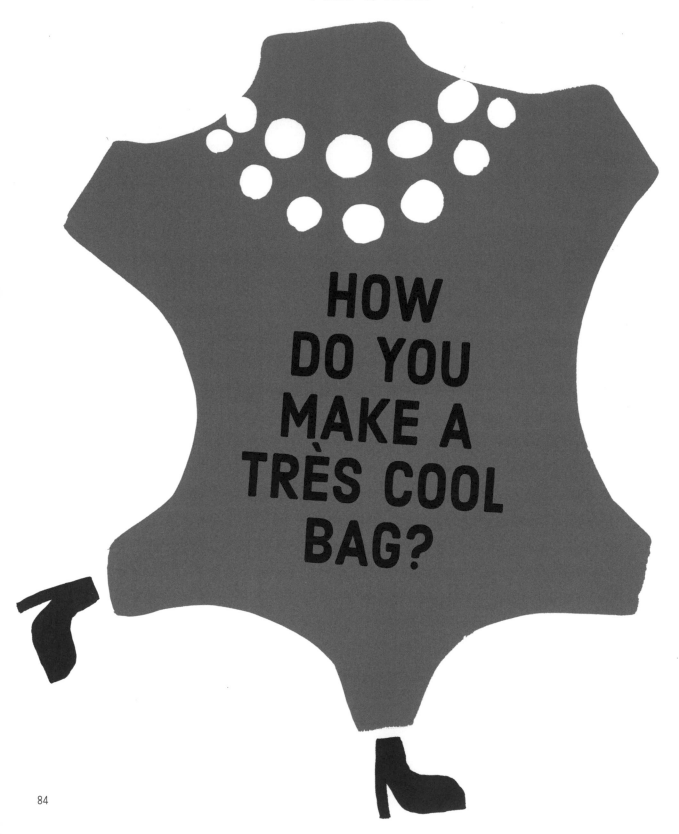

HOW
DO YOU
MAKE A
TRÈS COOL
BAG?

2 PIECES OF LEATHER OR SUEDE
FOR A BAG MEASURING
AROUND 13 X 18 CM

1 PIECE OF LEATHER OR
SUEDE MEASURING
AT LEAST 10 X 40 CM
(FRINGES AND LACES)

LEFTOVER COLORED LEATHER
TO MAKE DECORATIONS

DOUBLE-SIDED TAPE

HOLE PUNCH PLIERS

SCISSORS AND BOX CUTTER

MAKE A TRÈS COOL BAG

Look through your favorite magazines and cut out pictures that catch your eye. With this pile of ideas in the back of your mind, gather together the materials you need.

· You can find pieces of good leather at craft and fabric markets. Check the measurements. The leather needs to be supple, but not too thin. Can't choose between different colors? No problem! A multicolored bag is even more fun.

· Back at home, lay out your purchases on a table. Decide which piece of leather you want to use as the basis. You can use the others to decorate the bag and for making the laces and the strap.

· Cut two pieces of leather measuring approximately 13 x 18 cm.

· Mark out where the holes will go: two 1 cm holes from the edge on one side of the leather, and one dot at 1 cm intervals around the remaining edges (be as accurate as you can!). Do the same on the other piece of leather. Place the two pieces of leather together, keeping them in place with double-sided tape on the inside (along the sides and the bottom).

· Stick both halves together. Next, punch holes where you've drawn the dots. The hole shouldn't be bigger than 4 to 5 mm! If you're finding it hard to use the hole punch, try placing a piece of cardboard between the leather and the hole punch.

· Cut out about 10 laces measuring 0.5 cm wide and at least 40 cm long. Work the laces through the holes and finish them as shown in the diagram. For the straps, you'll need strips at least 1 cm wide, preferably as long as possible (you can easily alter the length).

· While making your bag, try it on a few times in front of the mirror. Then you'll see what works, and what you need to add or remove.

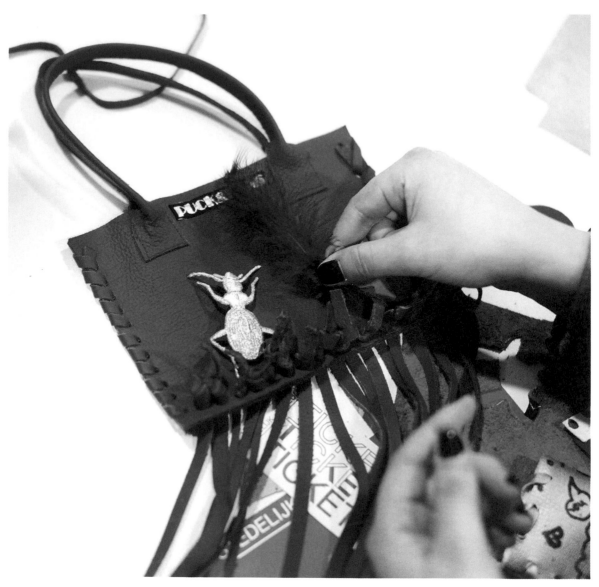

During Puck & Hans' workshop at the Stedelijk Museum

TIP *"Sometimes we begin with a piece of fabric we love; other times, we suddenly get an idea we want to explore, and pick the fabric that goes with it. What works really well is to cover a table with different fabrics and ask yourself what you want to do with them. We try to create an image from the chaos. If we get stuck, we take a break and visit a museum or watch a movie. Your ideas develop best when they have a chance to ferment in your subconscious. An idea will be brewing in the back of your mind. And then, all of a sudden, things fall into place and you can't wait to get started. Deadlines are another great way to get something done. If you decide to come up with an idea in an afternoon, you'll keep going until you're finished. The best designs are often created in the shortest time."*

1969/1970 winter collection fashion shoot

PUCK & HANS think that fashion should be unique, fantastic, and affordable. Hans used to be a photographer, but Puck introduced him to the world of fashion. In a time when there was still a difference between everyday clothes and fashion for special occasions, the duo took the fashion world by storm with designs that break every taboo. Their mission is to create distinctive, vibrant fashion, and ban boring forever. Puck & Hans have come up with tips for you to make a très cool bag as exciting (or boring) as you like.

HOW DO YOU DESIGN A SET OF LETTERS COLLABORATIVELY?

[AND SURVIVE THE GROWING PAINS]

TYPEFACE COLLABORATIVE GAME

You're going to make a typeface together.
Each player equally influences the end result. You never know in advance what the letters will look like. There's only one rule: make the letters as legible as you can. Ignore growing pains until you're all happy with the result. It's going to be exciting!

3 TO 5 PLAYERS

· Preparation
Place a sheet of paper on the table. Put the camera on the tripod on the table too, so the whole sheet is in the viewfinder. All players sit at the table with a pile of dots. Place two dots side by side in the middle of the table. Take turns to play. The oldest player begins. After each player's turn, the person closest to the tripod takes a photo of the sheet with dots. We begin with the letter A/a.

A TABLE

· Each turn
The player whose turn it is may:
Place one dot on the sheet to get the letter growing.
Move a dot to improve the shape of the letter (ouch?).

· When is it done?
It's never really over. If there's no room on the paper or if you get bored, you can start on the next letter. The typeface is finished when you've made all the letters of the alphabet. You can glue down the dots of the letters you want to keep and make a poster. By photographing each step of the letters game, you've actually made a short animation of how you created a typeface. Flip through the photos on the camera to see how the letters slowly grew and changed shape.

LOTS OF ROUND BLACK DOTS CUT OUT OF BLACK PAPER, WITH A DIAMETER OF ROUGHLY 7 CM (SQUARE OR RECTANGULAR SHAPES ARE FINE TOO)

26 SHEETS OF PAPER,
70 X 100 CM

A CAMERA ON A TRIPOD

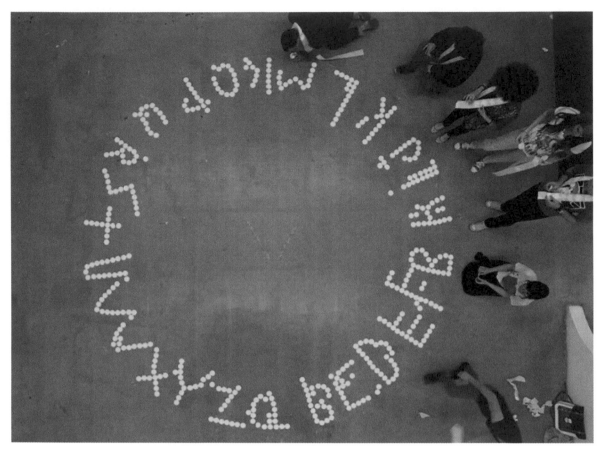

A workshop by Moniker, Sao Paolo. 2013

● TIP *"There are endless variations on this game. Because you can move other players' dots, you can correct mistakes. But if you like, you can change the rules so that dots can be placed, but not moved. Then, the mistakes will be plain to see, and you'll have to incorporate them into the design. You could also decide that only two dots can be moved. Afterwards, it's interesting to see how tiny changes to the rules affect the nature of the letters. You could also try making a whole word in one go, maybe as a birthday gift for a friend."*

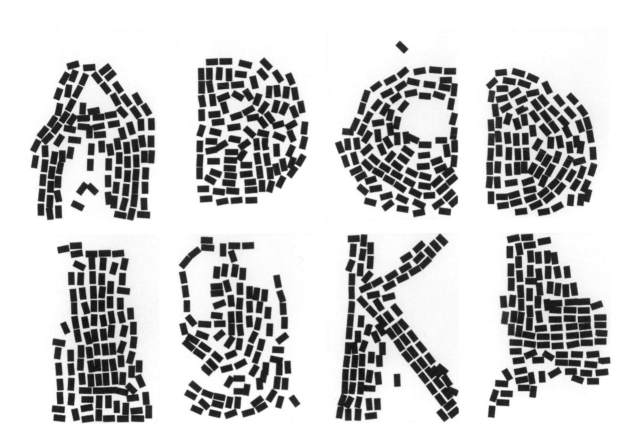

Results of a workshop by Moniker

MONIKER How does technology impact our everyday lives? How does collaboration work? These questions are ones that designers Luna Maurer, Roel Wouters, and Jonathan Puckey of Moniker love to tackle. So how do they do it? By, for instance, sharing a workshop online and inviting others to participate. And these collaborations grow Moniker's work in unexpected, but always organic, directions. One time it might lead to a film, the next to a video (clip) or an interactive web design. This workshop will show you how to design a typeface collaboratively. Will you survive the growing pains?

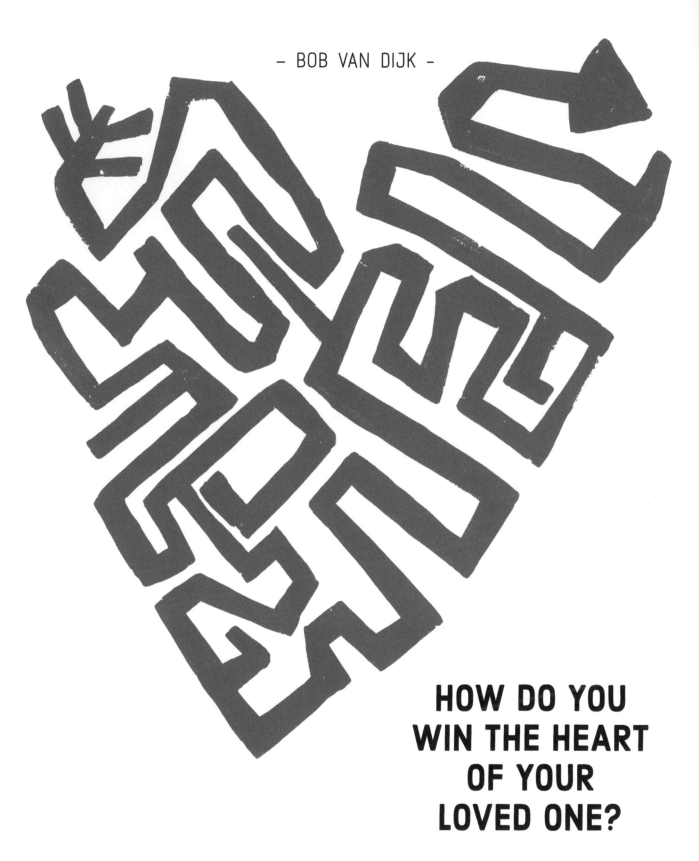

**HOW DO YOU
WIN THE HEART
OF YOUR
LOVED ONE?**

A BANNER TO WIN YOUR LOVED ONE'S HEART

Who have you fallen head-over-heels for? It could be your secret love, or your best friend, or your neighbor. What kinds of things does she or he like? What are their interests, hobbies, personality quirks? What makes this person so special to you?

· Jot down all the colors, shapes, words, or thoughts that pop into your head when you think of your special person. Choose five of them as the basis of your banner.

· Next, cut out all these ideas and inspirations from paper. Using scissors means you have to think fast, so keep the shapes simple and be imaginative. Don't worry – the cut-outs don't need to look like anything recognizable.

· Gather up your cut-outs. And look at the leftover paper – is there anything interesting you can use? Pick the most fun and eyecatching shapes.

· Now you're going to experiment and try out different ways to combine your shapes. Once you've found the perfect combination, staple, glue, or tape the shapes to the thread. All the while, think of your special person – their jokes, cute smile, or smart questions. Keep that in mind as you hang your shapes.

· And now, the grand finale! Surprise your special person with your banner. You can hang up the banner anonymously and let the person guess who made it, or find a romantic moment and present it in person. Love can be fun and festive, but someone has to put up the first banner.

TIP *"Be inspired! Throw all your energy and enthusiasm into making your banner. Visualize your romantic feelings in an amazing streamer, letting your emotions guide you as you cut out your shapes. Work quickly, don't be too neat. If you like, work a few jokes into your streamer. The more fun you have making your banner, the more energy it'll radiate. And don't forget to sing out loud the whole time!"*

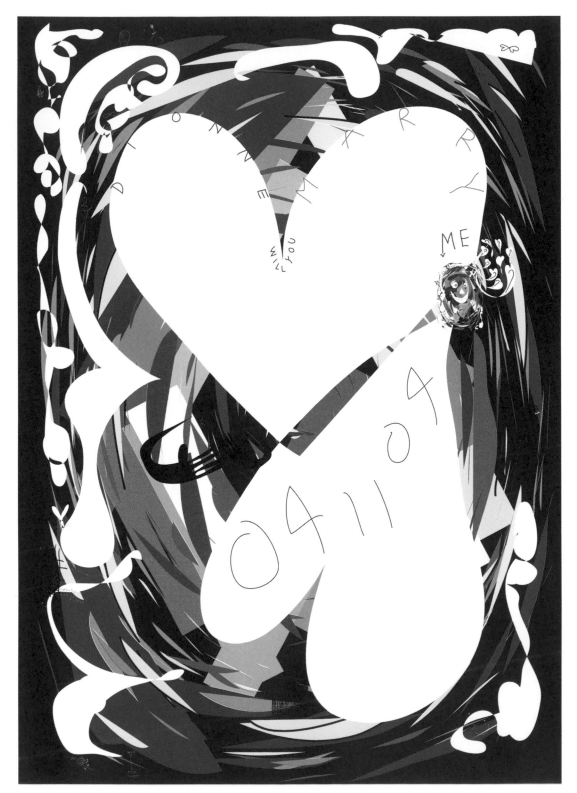

Love Poster, 2003

HOW DO YOU WIN THE HEART OF YOUR LOVED ONE?

BOB VAN DIJK is a graphic designer. He designs logos, books, and posters. But he's also an expert in the world of love. And it's clear to see. His designs are bursting with joy and butterflies in the stomach. He made a poster his shy friend could use to propose to his girlfriend. (It worked! The couple now have four children.) Does your pulse race when you think of that special person? Bob will show you how to win their heart. So admit it...who's your secret love?

HOW DO YOU TAKE
A NATURAL PORTRAIT?

A PERSON TO PHOTOGRAPH

BACKGROUND OF YOUR CHOICE

NATURAL LIGHT

TAKING A NATURAL PORTRAIT

Learn to look beyond the pose, and discover how to take natural self-portraits.

· Study photographic portraits in a museum, photo books, or photographic portraits you find online. Pay particular attention to color, pose, distance, and how the portrait is framed. What appeals to you and what doesn't? When does a portrait resonate with you? What elements can you use for the portrait you're going to take?

· Think of someone you'd like to make a portrait of. It could be your best friend, a classmate, or perhaps someone you've seen on the street for the first time. You could also find a model through social media. Or would you like a portrait of yourself as you really are?

· Observe your model carefully. Does he or she convey a particular mood or characteristic? Connect with them; chat for a while. Is your sitter shy, bold, dramatic, gentle, or cheeky? Which emotion comes through strongest? And how will this influence the way you'll portray your sitter?

· Next, you need to find the right background. Perhaps a garden full of flowers, or maybe a wall? Any background is fine, but choose carefully. The busier the background the more it will divert attention away from the sitter's face. A neutral background could be more powerful. You can always remove any unwanted elements in the background.

· Put your model at ease. Let him or her find a pose that feels natural and comfortable. You don't need to offer many suggestions. Smiling's not necessary. Say something like, "Yes, that's great, hold that pose for a moment." Brightly patterned blouse? Swap it for a plain one. And make sure the light is right – think about the play of sun and shadow.

→

· The standard camera lens generally corresponds to what your eye sees, which makes it the most natural kind of lens. If you're using a wideangle lens or telephoto lens, you'll need to stand closer to or farther away from your model. What lens will you choose, and why? Photography takes time and patience; you can't rush it. And always keep an eye on your model. The unguarded moments can be important. That's when your sitter's "mask" might slip. Click away! Photos of people looking too posed are often less interesting.

· Take full-length shots of your model as well as close-ups.

· Check your results from time to time. Are you pleased with the composition? The colors, the proportions? Keep experimenting until you're satisfied.

BRIGHTLY PATTERNED BLOUSE?
SWAP IT FOR A PLAIN ONE.

TIP *"You need examples so you can stand on your own two feet later on. When I was a young photography student, I learned a lot from looking at the work of other photographers. Rembrandt was, and still is, one of my inspirations, too. The people he painted are so real. He captures the moment, stripping away all the tricks and artifice. Photography's always a bit of a quest: to take a really good photograph you often have to take a lot of bad ones. Develop your own approach to light, or subjectmatter, for instance. And it's handy to have confidence. At first, I didn't dare ask anyone to pose for me. Make a genuine connection with people, because that's what you're asking them to do for you. During a photo shoot, the fewer people I have around the better. Otherwise it's too distracting."*

RINEKE DIJKSTRA Years ago, Rineke Dijkstra made a self-portrait after swimming thirty lengths. There, in that swimming pool, her photography style was born. Too exhausted to strike a pose, she stood rather awkwardly. And it worked.
Rineke makes portraits of people on the beach, adolescents in the park, matadors after a bullfight, and new mothers. All the portraits are taken in an everyday setting. Every person is photographed at the moment they break their pose, or haven't yet found one. Rineke's approach to taking photographs has taught her to look much more closely. In the body language of the people that Rineke photographs you can see their confidence and the circumstances they live in.

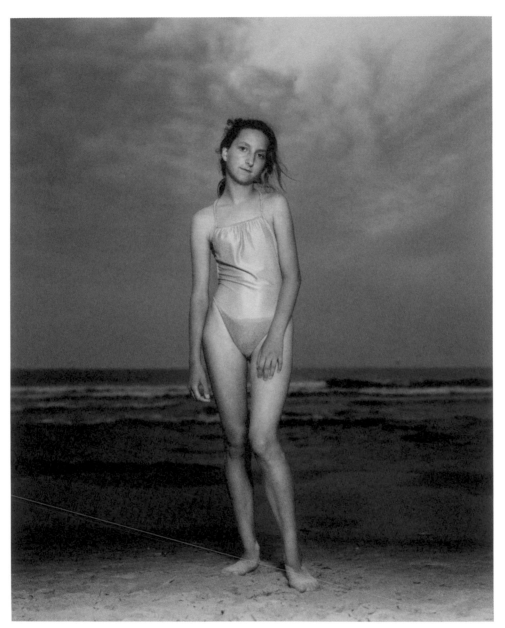

Kolobrzeg, Poland, 26 July 1992, 1992

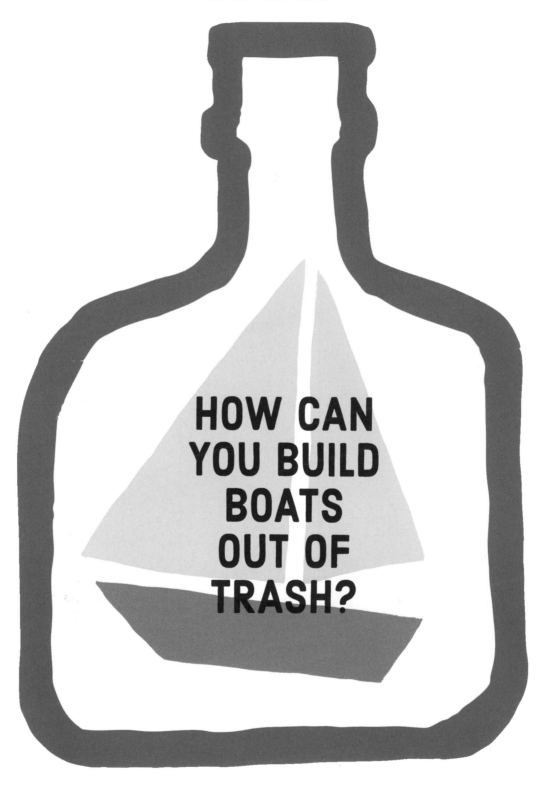

HOW CAN
YOU BUILD
BOATS
OUT OF
TRASH?

WHAT YOU NEED

AN EMPTY, FLAT PLASTIC
BOTTLE WITH A CAP
(LIKE A SHAMPOO BOTTLE)

TWO THICK
RUBBER BANDS

COLORED TAPE

AN OLD PLASTIC BAG OR
PIECE OF KITE FABRIC

A CLOTHES PEG OR
A BLOCK WITH A HOLE

A WATER-RESISTANT
MARKER PEN

A CIRCULAR STICK OR TWIG
ROUGHLY 20 CM LONG

A LITTLE WEIGHT
(A PEBBLE OR WOODEN BLOCK)

SCISSORS

BUILD A BOTTLE-BOAT

Ship ahoy!

· Clean the empty plastic bottle and remove the label.

· Now put the rubber bands around the bottle, making sure they're roughly in the middle.

· Next, use the elastic bands to hold in place the clothes peg, or the wooden block with the hole. This is the basis of your boat.

· Time to make the sail. Cut out a triangle from the plastic bag or piece of kite fabric. The bottom of the triangle should be about 20 cm wide and approximately 18 cm high. Place the stick in the middle of your triangle and fold the triangle in two. That's your mast. Now fix it in place using glue or adhesive tape.

· If you like, you can brighten up the sail using pieces of tape or a water-resistant marker pen.

· Place the foot of the mast with the sail in the block with the hole, or fasten it in place with the clothes peg.

· Your boat's nearly ready but you need to stabilize it. You can use a bit of stone or wood as a weight. Clamp it in place between the rubber bands, on the underside of the bottle.

TIP *"Fix a thin piece of string to your boat so it doesn't float away and get lost. The best bottles to use for making a boat are flat ones, the kind made for shampoo or shower gel. Buy a bottle in a bright color and wash your hair every day so you won't have to wait long to build your boat. Empty bottle? Now you can begin. If you have a large bottle, you could make two sails. And if you tape two round bottles together, you've made a catamaran."*

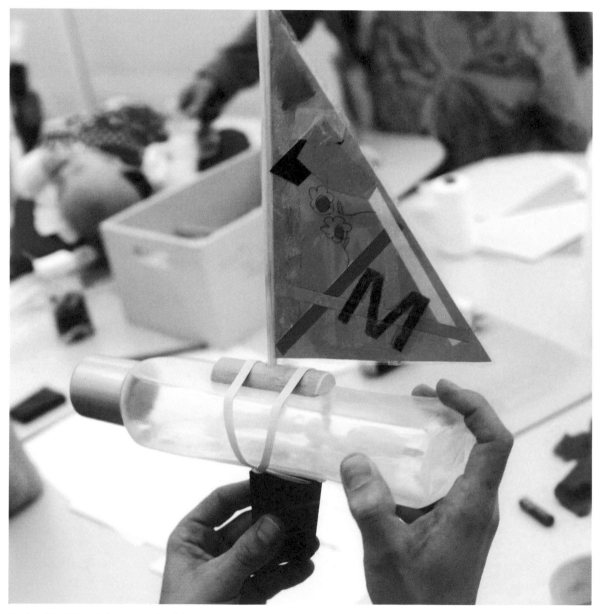

During Floris' workshop at the Stedelijk Museum

HOW CAN YOU BUILD BOATS OUT OF TRASH?

CARtools, 2015

ArchiBlocks, 2014

FLORIS HOVERS works in an old concrete factory in a little Dutch village. The factory once belonged to his father. Now, it's a workshop where Floris makes lamps, chairs, and tables, as well as construction kits, model cars, and boats made from bottles. Most of all, he likes to make everything himself. His favorite word is "craft." He can make a stool out of rope and wood. And turn a stick into a lamp. When he sees an empty bottle on the street, he picks up a few sticks and bits of trash...and the empty bottle suddenly has a sail, a mast, and a rudder.

HOW DO YOU DRAW A WORD? AND HOW DO YOU DRAW A POEM?

YOU CAN DO
THIS WORKSHOP WITH
TWO OR MORE PEOPLE

SHEETS OF WHITE PAPER (A4)

PENCIL

CAMERA

A STOPWATCH
OR HOURGLASS

A SELECTION OF
DIFFERENT WORDS

PART 1: DRAWING A WORD

Decide who does what – one of you will use the time to write down a series of words. Choose words that are related, or have no connection whatsoever. And don't reveal which words you've chosen.

· The sketcher places the sheet of paper in front of them. Put pencil to paper – and don't lift the pencil off the page while drawing.

· The other person reads the chosen words out loud. And gives the sketcher a short amount of time in which to draw the word, then the next one (without ever taking the pencil from the paper).

· Meanwhile, the person who read the words aloud takes photos of the different wordsketches, entangled together, and the sketcher, too. This gives you a record of how that particular person concentrates.

· How did it go? Swap roles and/or repeat, with a different series of words.

PART 2: DRAWING A POEM

What you need: As above, but this time, choose a poem that the reader has always wanted to see as an image.

· Change the roles again. Who reads a favorite poem, and who's going to draw?

· Read the poem twice. The sketcher listens.

· Again, the drawer translates the poem into an image without taking the pencil from the paper.

· Talk about the sketch together. Could it be used as the basis of a sculpture or other 3D image?

· Give the sketch a title.

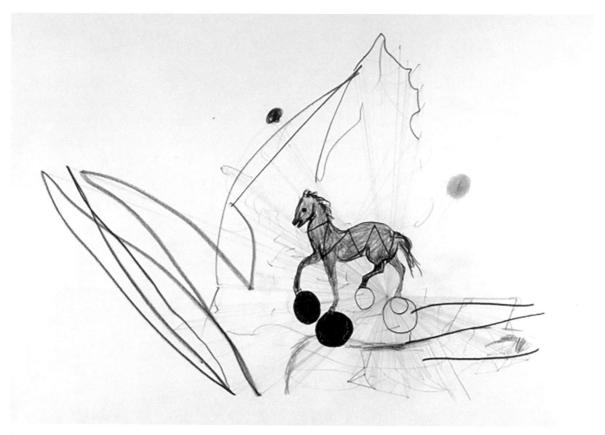

Drawing with Vanishing Point/ Drawing with Cemetery Horse, 1998

TIP *"Drawings are often nothing more than a couple of small gestures. But they still resonate with you. Consider an empty space (like a sheet of white paper) as a magical space. What do you want the viewer to feel? In your drawings, try to find a language that doesn't consist of words, but that moves you, and stands for what you believe is important in life. Titles can help bring the image closer to the viewer – which themes have you touched on, and what emotions have you sparked?"*

MARK MANDERS Mark Manders sometimes makes more than a hundred sketches before he creates an image, drawing, or sculpture. Mark's sketches are inspired by a language. His sculptures take shape very gradually. Words and images appear and disappear. He starts by generating a lot of ideas, in his head and in his studio. When a poem materializes, he draws. This workshop will show you how you can draw poetry, too.

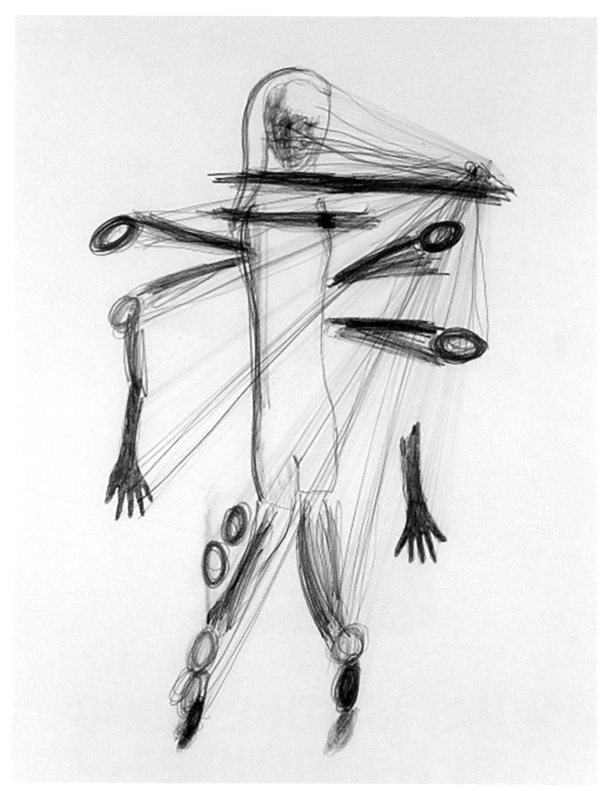

Four Drawings with Vanishing Points, 2005

WHAT IS YOUR THING IN THE FUTURE?

MAKING THE THING FOR THE FUTURE

Imagine what the world will be like in 30 years. What kind of problems will we be dealing with? Overpopulation and tsunamis? Or is the world a better place? Have they invented a pill for everlasting health? Is global warming a thing of the past?

Try to imagine what your world looks like. What hangs, stands or flies there? What do people eat and drink? What do they do to relax?

Now think of what your future world needs. What can you invent for future generations of earthlings? It could be anything. It might have a practical purpose, or be totally useless; it could look real, or like nothing you've ever seen.

**CREATE SOMETHING YOU THINK IS IMPOSSIBLE TO MAKE.
BECAUSE WHEN YOU MAKE IT, IT IS POSSIBLE!**

USE WHATEVER YOU LIKE,
HOWEVER YOU LIKE, TO MAKE
YOUR THING FOR THE FUTURE

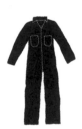

TIP *"You can turn your dream into reality – I realized that when I was young. I decided to make art and I've never stopped. I work intuitively. When I get an idea, I start sketching right away. I always think about things that don't yet exist. Something no one's ever thought was needed. Something that isn't even possible. Never be held back by limitations. Dare to dream big. If you really want something you have to work hard to get it, but it'll be worth it."*

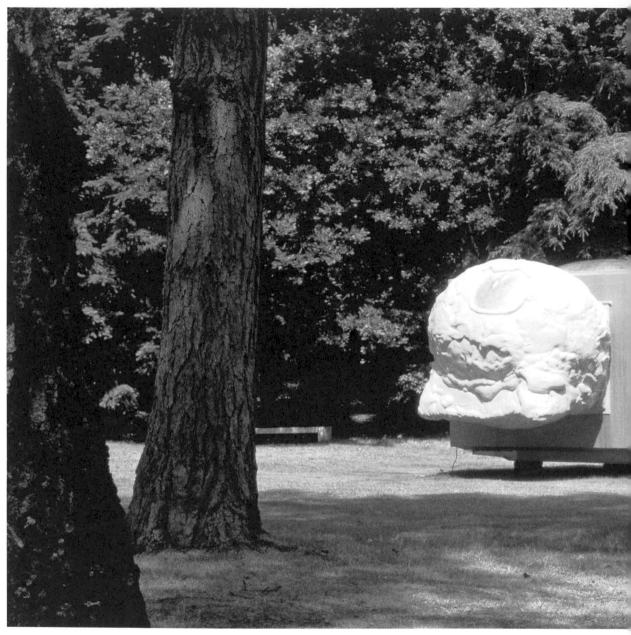

Mobile home for the Kröller Möller Museum, 1995

JOEP VAN LIESHOUT likes wearing overalls, running marathons, and wanted to become a scientist. But Joep became an artist. An inventor. He has a workspace hidden away in a big industrial warehouse in the ports of Rotterdam: Atelier Van Lieshout. That's where he makes his artworks, with a group of other people. His art is often made from brightly colored polyester. Joep is fascinated by the

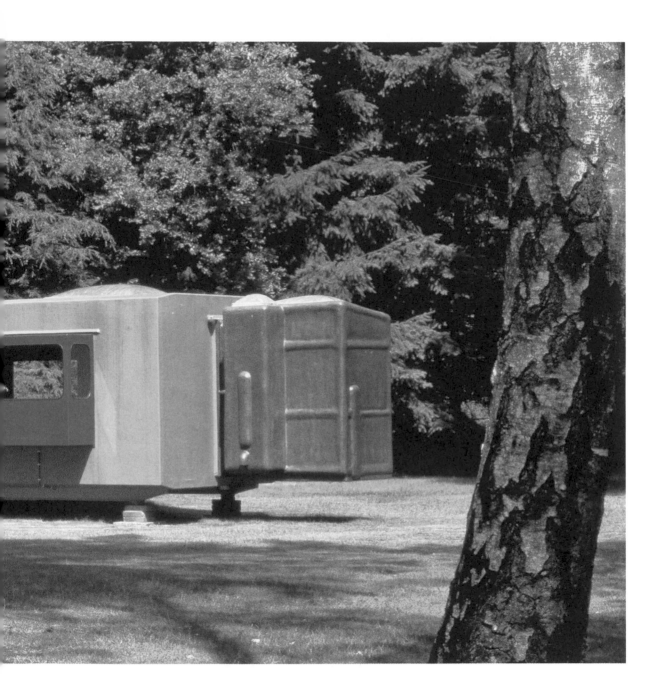

idea that the earth is getting fuller and fuller. His work raises questions about the world we live in to-day, and offers solutions for the future. He makes machines and objects that future generations might need. Once, he even set up his ideal state: "AVL-Ville". A village with its own constitution and flag, where you pay with a coin called the "AVL".

HUNGRY FOR MORE?

With their fresh approaches, imaginative perspectives, and innovative assignments, artists are crucial to the development of programs for the Stedelijk Museum's public. The collaboration results in engaging classroom materials and fun, inspiring activities for the families, youth, and adults who visit the museum. We are particularly proud of the many hundreds of workshops that we have developed with artists over the years. And now, we are delighted to be able to share the twenty-three workshops in this book with the rest of the world.

But what makes artists' ideas so compelling? They share their questions, strategies, and thoughts – and invite you to enter their worlds. For all of the museum staff, but particularly the Education & Visitors Services team, our partnership with artists offers a boundless source of energy, sparking curiosity and wonder in both the artist and the museum visitor.

Want to learn more about the Stedelijk Museum programs?
Go to **www.stedelijk.nl/educatie**

EXTENDED CAPTIONS

Rop van Mierlo, 'Panda', from the series *Some Logic*, 2014, ink and watercolor on paper. Courtesy Rop van Mierlo
P.16

Rop van Mierlo, 'Elephant' , from the series *Wild Animals*, 2014, 2014, ink and watercolor on paper. Courtesy Rop van Mierlo
P.17

Marijke van Warmerdam, *Caught*, 2006, 30 x 40 cm, photographs, di-bond, wooden sheep. From: *Het schaap en de zwaan, de zwaan en het schaap* (Amsterdam: Uitgeverij Van Waveren), 2005. Courtesy Marijke van Warmerdam
P.24

Marijke van Warmerdam, *Take off*, 2005, 100 x 66 cm, screenprint on plastic mirror, di-bond. From: *Het schaap en de zwaan, de zwaan en het schaap* (Amsterdam: Uitgeverij Van Waveren), 2005. Courtesy Marijke van Warmerdam
P.25

Marlene Dumas, *Magdalena (Newman's Zip)*, 1995, 1995, oil on canvas, 300.5 x 101.5 cm. Collection Stedelijk Museum, Amsterdam, gift of the Stichting Vrienden van het Stedelijk Museum
P.20

Marlene Dumas, *Magdalena (Manet's Queen/Queen of Spades)*, 1995, oil on canvas, 300.5 x 101.5 cm. Collection Stedelijk Museum, Amsterdam, gift of the Stichting Vrienden van het Stedelijk Museum
P.20

Jan Rothuizen, 'Het Leidseplein', India ink on paper, 50 x 65 cm. From: *The Soft Atlas of Amsterdam* (Amsterdam: Nieuw Amsterdam), 2014. Courtesy Jan Rothuizen
P.82-83

Johannes Schwartz, 'Bear Food', chromogenic C-print, from the series *Tiergarten*, 2014. Courtesy Johannes Schwartz
P.39

Maria Barnas, *The Things I Should Have Said*, 2013, dough. Courtesy Maria Barnas
P.46

Marcel Wanders, *Knotted Chair (prototype no. 5)*, lounge chair, design 1995-1996, knotted aramide fibre cord with carbon core, secured with epoxy resin, sand blasted. Collection Stedelijk Museum, Amsterdam
P.51

Marcel Wanders, *Airborne Snotty Vase Coryza*, vase, 2001, 3D printed with the SLS technique, Personal Editions. Collection Stedelijk Museum, Amsterdam.
P.51

Lawrence Weiner, *SHOT TO HELL...*, 1995, enamelled metal, 107 x 66 x 3 cm. Collection Stedelijk Museum, Amsterdam
P.54

Lawrence Weiner, *WHAT IS SET UPON THE TABLE SITS UPON THE TABLE*, 1960-1962/1982, kalksteen op een houten tafel, 133 x 91 x 76 cm. Collection Stedelijk Museum, Amsterdam
P.54

Jantje Fleischhut, *To Be in Orbit*, necklace, 2011, silver, pearls, copper, resin, plastic. Courtesy Jantje Fleischhut
P.55

Mick La Rock, Bellamyplein, Amsterdam, 2012. Courtesy Mick La Rock
P.63

Ineke Hans, *Seven Chairs in Seven Days*, chairs, 1993-1995, underlayment, designer and producer Ineke Hans, producer Ata, Arnhem. Collection Stedelijk Museum, Amsterdam, gift of Axel and Heike Varekamp, Blaricum
P.67

Ineke Hans, Eat Your Heart Out, 1997, laminated plywood. Collection Stedelijk Museum, Amsterdam, acquired with the generous support of the Mondriaan Fund
P.68-69

Liam Gillick, *All-Imitate-Act*, Museumsquare, Amsterdam, 2015, concept for installation in eleven panels. Collection Stedelijk Museum, Amsterdam
P.73

Persijn Broersen & Margit Lukács, *Ruins in Reverse*, 2014, 2014, installation with photographic wallpaper and sound, soundscape Natalia Domingues Rangel. Collection Stedelijk Museum, Amsterdam
P.78-79

Bob van Dijk, *Love Poster*, 2003, offset, 94 x 59.5 cm. Collection Stedelijk Museum, Amsterdam, gift of Bob van Dijk, The Hague
P.94

Rineke Dijkstra, *Kolobrzeg, Polen, 26 juli 1992*, 1992, chromogenic C-print, 96.5 x 75.5 cm. Collection Stedelijk Museum, Amsterdam
P.99

Mark Manders, *Drawing with Vanishing Point*, 2005, , pencil on paper, 21 x 30 cm. Courtesy Mark Manders and Zeno X Gallery, Antwerpen
P.106

Mark Manders, *Drawing with Vanishing Point*, 2011, 2011, pencil on paper, 50 x 65 cm. Collection Irish Museum of Modern Art, Dublin
P.107

Floris Hovers, *CARtools*, 2015, construction set for wooden cars. Producer: Magis. Courtesy Floris Hovers
P.103

Floris Hovers, *ArchiBlocks*, set of wooden blocks, 2012. Courtesy Floris Hovers
P.103

Joep van Lieshout, *Mobile Home for Kröller-Müller*, 1995, polyester, dimensions variable. Collection Kröller-Müller Museum, Otterlo
P.110-111

IMAGE CREDITS

Paul Andriesse
P.21

Atelier van Lieshout
P.110-111

Persijn Broersen & Margit Lukács
P.78-79

Tomek Dersu Aaron
P.15, 42, 50, 76, 86, 102

Bob van Dijk
P.94

Jantje Fleischhut
P.59

Issa Kerremans
P.35

Mark Manders/ Zeno X Gallery
P.106, 107

Mick La Rock
P.62, 63

Moniker
P.90, 91

Andrea Rossetti
P.73

Ron Steemers
P.68-69

Giene Steeneman
P.43

Piet Oudolf
P.30, 31

Jan Rothuizen
P.82-83

Stedelijk Museum, Amsterdam
P.20, 51, 54-55, 67, 99

Marcel Wanders
P.51 (LEFT)

COLOPHON

Concept, texts and compilation
Rixt Hulshoff Pol and Hanna Piksen

Text editing
Saskia du Bois

Copy editing
Rixt Hulshoff Pol, Hanna Piksen,
Sophie Tates

Project management
Sophie Tates

With thanks to:
The artists and designers, Marie-Claire van Bracht,
Marian Cramer, Karin van Gilst,
Marie-José Raven, Beatrix Ruf, Irma de Vries
and Katie Wolters

Graphic design and illustrations
You May Also Like This
Marjolijn Stappers

Publisher
BIS Publishers in collaboration with
Stedelijk Museum, Amsterdam

BIS Publishers
Building Het Sieraad
Postjesweg 1
1057 DT Amsterdam
The Netherlands
T +31 (0)20 515 02 30
bis@bispublishers.com
www.bispublishers.com

www.stedelijk.nl

ISBN 978 90 6369 416 6
Stedelijk Museum catalogue number: 919

B/SPUBLISHERS

This book was made possible by a generous contribution from
the Stichting Vrienden van het Stedelijk Museum. Workshops
at the Stedelijk Museum are supported by the Freek & Hella
de Jonge Stichting. Thanks to their support, children are
introduced to art and artists on a weekly basis.

The Stedelijk Museum is supported by:

Principal sponsor Partner

Rabobank